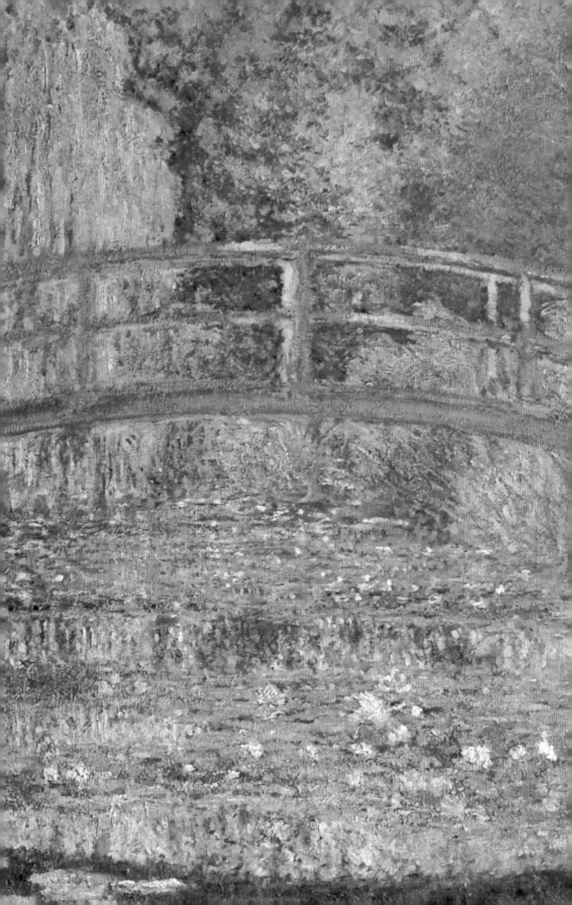

Karin Sagner-Düchting

Monet at Giverny

Prestel

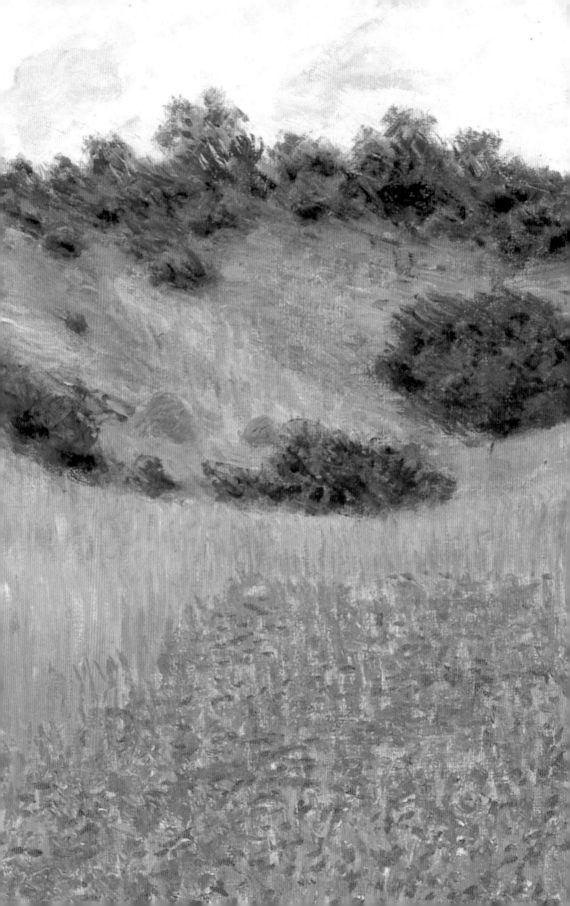

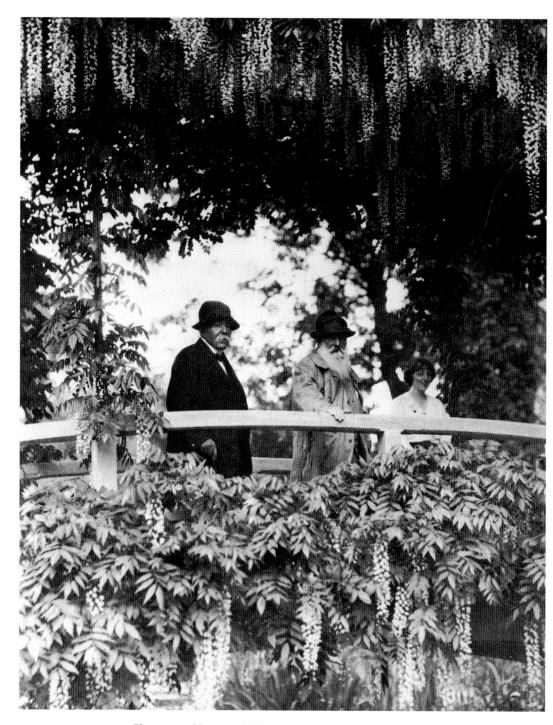

Clemenceau, Monet, and Lily Butler on the Japanese bridge, 1921

Between the house and the road, floral clusters of every magical shade in the spectrum descend from the vault of heaven in a series of flaming cascades—torrents of luminous color that appeal to the painter's eye at certain times of day. Monet loved flowers: for themselves, for their airy, delicate conformation, for the love they radiate with such disdain, for the abundant shafts of soft or vivid color that so defiantly flaunt themselves amid giant rose trees where those weary of a mundane existence can feast their eyes.

Together with some trees, a wall surmounted by railings shields the garden from the gaze of passersby on the sunken road that skirts it. Monet was familiar with every clump of flowers, discreet or gaudy, and every morning, as he trod those modest paths accessible only to himself, he never omitted to offer them the first, ritual salutation enjoined by his insatiable eye.

By unlocking a gate, one could cross the embankment bordering the railroad track, which was entirely screened by a rampart of rhododendrons and a latticework of climbing roses. Passengers were treated to the sight of a mass of blossoms, and Monet, engrossed in the mirrorlike surface of his pool only a few yards away, would not even hear the train pass by.

Therein, to be precise, lies the miracle of the *Waterlily* paintings, which portray things in a way that differs from our prior observation of them: in novel relationships and in a new light, as ever-changing aspects of a universe that is unaware of itself yet self-expressive by way of our own sensations. By admitting to hitherto unfamiliar emotions, are we not gaining new insights into mute infinity and penetrating deeper into the impenetrable world itself? That is what Monet discerned when looking at the sky reflected in his pool, and that is what he wished us, in our turn, to be shown through the medium of his painting. Many will reject this notion and most will be indifferent to it. The

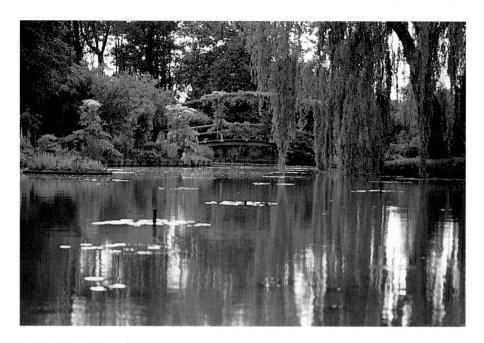

Monet's garden at Giverny, 1994

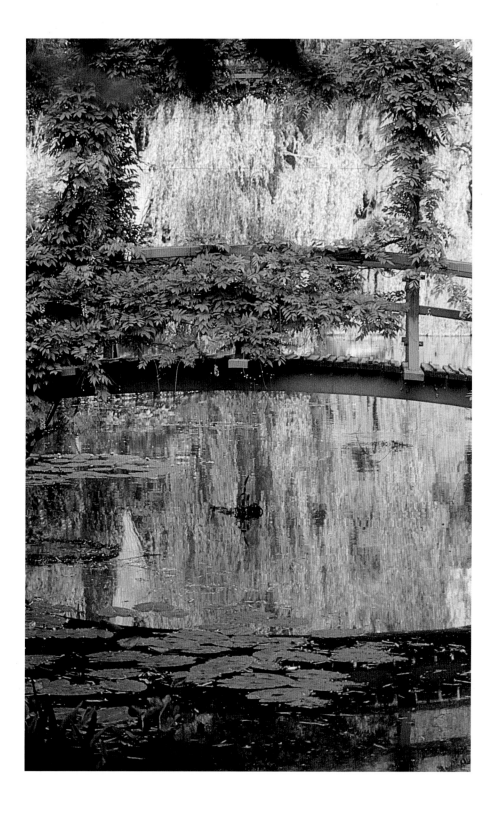

"public," you will say, is little more than a noisy chorus of misapprehension. Let us, at all events, be grateful for the silence that is one of the first symptoms of admiration.

I shall say nothing, at this stage, about Monet's technique. It is what it could only be, since it grants us an ecstatic awareness of the way in which he developed reality. No one confronted by his sensational *Waterlilies* can fail to experience this feeling, perhaps without fully or immediately comprehending it.

Georges Clemenceau, 1926

Monet and Giverny

To the minds of many, Claude Monet's singular style typifies French Impressionist painting. He devoted nearly sixty years of his long life to grappling hard with fundamental questions relating to the perception and depiction of landscape, and he ceaselessly sought novel solutions.

Except in some of his early works, figurative representation was secondary in Monet's art. The human form invariably appeared as part of its natural surroundings, but from 1886 he dispensed with it altogether. In recording his perceptions of the natural world he attained a quite extraordinary range of expression which, in his late work, far transcended Impressionism. These late works, which Monet painted during the last thirty years of his life under the influence of the grandiose water landscapes at Giverny, represent his modern period.

In 1883, after many restless years marked by personal problems and changes of abode, Monet settled at Giverny, a small village on the Seine some 40 miles northwest of Paris. He was then 43 years old and, as a new phase in his life as a painter began, the "Monet legend" began to take shape. During this period he attained the artistic success that finally brought him relative financial security, and his personal problems, notably his relationship with Alice Hoschedé, were resolved. It was in the garden and water landscapes of Giverny and its environs that Monet found the "ideal" landscape motifs to which he had always been drawn.

Seven years later, in 1890, he purchased the house that he had been renting there, and three years later he enlarged the garden by adding a pond. After Monet's death in 1926, the property quickly deteriorated. In 1966 his son Michel bequeathed it to the Académie des Beaux-Arts. Meticulously restored and renovated thereafter, the garden and the house, now known as the Musée Claude Monet, have been open to the pub-

lic since 1980. From every point of view, they are well worth visiting.[1]

Most of the alterations and additions that Monet made to the house and garden from the 1890s onward—the studio buildings, the skillfully designed water garden, and the wooden bridge in the Japanese style, for instance—are directly associated with Monet's waterlily paintings, the highlight of his œuvre. From the outset, Monet planned these paintings, of which there are more than 250, as a series and intended them to be permanently mounted as a form of interior decoration. In 1927 this was finally realized when a number of selected waterlily pictures were installed in the Musée de l'Orangerie, Paris, where art-loving tourists still flock today.[2] For many important twentieth-century painters, this gallery became the "Sistine Chapel" of modern art.

Monet spent his boyhood at Le Havre, on the coast of Normandy, and it was there that his love of the sea and of water, a

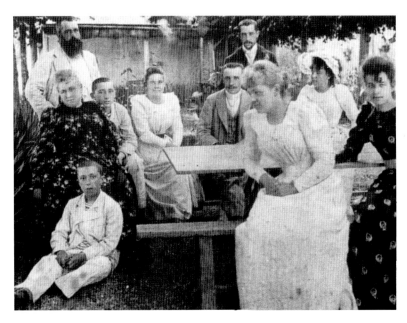

The Monet-Hoschedé family, Monet is at back left

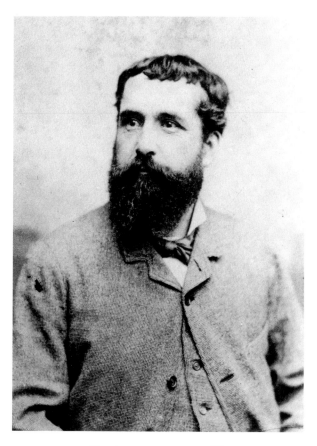

Monet as a young man, 1883

motif that runs throughout his work, was born. All his sub-
sequent homes—at Argenteuil (1872-78), Vétheuil (1878-81),
Poissy (1881-83), and Giverny (from 1883)—were situated on
the banks of the Seine, which, as far downstream as the Nor-
mandy coast, were his favorite painting locations. At Argenteuil
he produced the paintings that are commonly associated with
French Impressionism: small scenes from daily life that are col-
orful, spontaneous, and compositionally uninhibited.[3] Monet's
years at Argenteuil coincided with the apogee of French Impres-
sionism (it was already on the wane by 1880) but the paintings
he produced there represent only one of many facets of the

work of an artist who, in tackling central problems of landscape painting, achieved new and exciting results.

In 1878, when Monet moved from Argenteuil to Vétheuil with his wife Camille and their two sons, Jean and Michel, Alice Hoschedé and her six children came too. Ernest Hoschedé, formerly a well-to-do patron of the Impressionists and of Monet in particular, had gone bankrupt in 1877. Completely destitute and hounded by his creditors, he lay low at Vétheuil for a while, but soon returned to Paris to rebuild his fortunes. Ignoring his pleas for her to accompany him, Alice remained with Monet. The desire to look after the two boys and Camille, who was gravely ill, was certainly not her sole motive for staying. She and

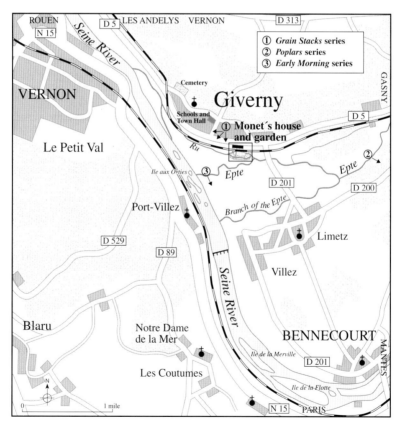

Giverny and surrounding area

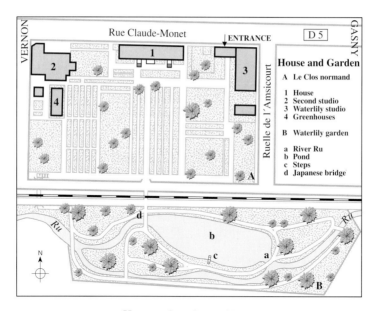

House and garden at Giverny

Monet had most likely become lovers as early as 1876, while the artist was staying at Château Rottenbourg, the Hoschedés' residence near Montgeron. After Camille's death in 1879, which severely affected Monet's work, Alice not only mothered Jean and Michel but unhesitatingly followed Monet to Poissy in 1882. They did not legalize their relationship, which the local country-folk regarded with suspicion, until 1892, after Ernest Hoschedé's death. Monet did not linger long at "awful, ill-fated Poissy." He did not find the town or its surroundings conducive to painting. In 1883, forced to move out of his house there because the rent was in arrears, he was only too glad to look around for a new abode. Since he continued to attend the Im-pressionists' monthly dinners at the Café Riche, this could not be too far from Paris. His search took him in the direction of Normandy, and it was while traveling by train from Vernon to Gisors that he discovered a little village set in idyllic countryside. This was Giverny, which then had fewer than 300 inhabitants. Writing in May 1883 to his dealer, Paul Durand-Ruel,[4] without whose generous financial assistance he could not have moved

Iris Field at Giverny, 1887

there at all, he expressed delight both with the place and the whole area.

The village of Giverny, which lay on a lateral arm of the Seine and was surrounded by marshes and meadows, woods and low hills, was an ideal environment for a painter. With surprising alacrity Monet found a house to rent with four rooms on each of its two floors and a barn on the western side (his first studio)—a house that was in fact spacious enough to accommodate a family that had by then grown to ten. It was situated in a part of the village known as Le Pressoir (the Wine Press), and was enclosed by a large garden with a stone wall and orchard, a so-called *Le Clos normand.* It was bounded at the rear by Rue de Haut (now Rue Claude Monet) and, on the garden side, by Chemin du Roy and the Vernon-Gisors railroad track (see map on p. 15). Accompanied by some of the children, Monet moved in on April 29, 1883, using his houseboat, which doubled as a floating studio, as an inexpensive means of transportation. Alice followed the next day. The local inhabitants greeted the artist and his unconventional ménage with suspicion, indeed, disap-

Opposite page: Meadows at Giverny, 1888 (detail)

proval, little knowing how greatly he would contribute to the subsequent fame of their village.

It took some time to carry out the work attendant on this move, including the conversion of the west wing of the house into a studio, the reshaping of the garden, and the construction of a barn on the banks of the Seine, with the result that Monet was unable to think of painting again until June 1883.

I had to have a barn built on the banks of the Seine to house my boats and store my easels and canvases. This building is finished.... All I can think of now is painting, because dealing with my boats has been a great distraction. I had to accommodate them safely because the Seine is some distance from the house. There was also the gardening, which claimed all my time, because I should like to grow some flowers in order to be able to paint in bad weather as well.[5]

Poppy Field, 1873

Poppy Fields at Giverny, 1885

Monet was reluctant to paint his immediate surroundings, however, and initially concentrated on more familiar ones. He painted river landscapes in the neighborhood of Port-Villez and views across the Seine of the church at Vernon, both of them places situated on the opposite bank. Compositionally, these paintings follow on from similar ones Monet produced at Vétheuil. It was not until August 1884, after he had been commissioned to decorate the doors in Durand-Ruel's salon, for which he enlisted flower motifs from his garden, that Monet turned to subject matter from Giverny. The first was some haystacks on La Prairie, the meadow behind his house on the far side of the railroad embankment and the Ru River. There followed landscapes at Jeufosse in the fall of 1884, views of Giverny under snow the same winter, and paintings of nearby meadows and fields in 1885, 1887, and 1888, among them *Poppy Fields at Giverny* (p. 19) and *Iris Field at Giverny* (above). Comparison with the *Poppy Field* (p. 18) painted at Argenteuil in 1873 clearly illustrates the development of Monet's art. The work depicts a meadow with poppies and human figures set in a cheerful landscape with a very low skyline that lends it spatial depth; in the painting of 1885, by contrast, Monet marries representation with an incipient element of abstraction, and his brushwork and coloration have become increasingly autonomous. The poppies now appear as a pattern of stylized dabs of red set against an interplay of greens, and the grassy field is conveyed by a scattering of vertical brushstrokes. Spatial depth is restricted by the very high skyline, which throws the eye back and creates an impression of symmetrically arranged expanses of color. The landscape theme turns out to be a pretext, and topographical interest becomes wholly subordinate. Subtle gradations of complementary colors reveal Monet to be a consummate colorist with as perfect a mastery of the chromatic keyboard as Eugène Delacroix, for whom he cherished a lifelong admiration.[6] Always averse to theory, he achieved this perfection without the scientific, systematic use of color that was coming into vogue among

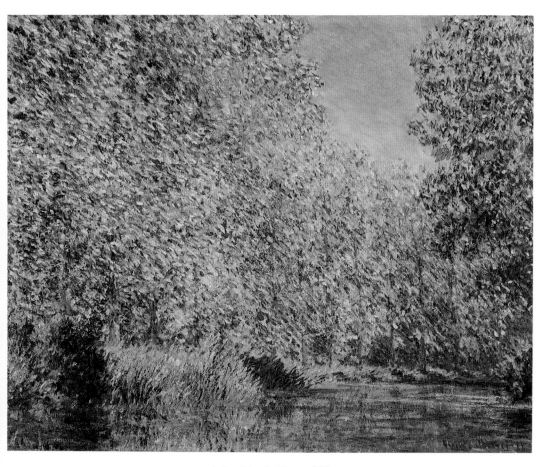

A Bend in the Epte, 1888

painters such as Georges Seurat, Paul Signac and Camille Pissarro, who sought to take one step further the Impressionist principle of divisionism, the juxtaposition of unmixed pigments, by turning it into a formalized, schematic technique. As a result, they also stumbled upon the latest findings on color theory and optics.[7] Another painting that originated in the neighborhood of Giverny in 1888 was *A Bend in the Epte* (p. 21); here, because of the artist's unusual viewpoint, shimmering foliage occupies almost the whole of the canvas. This rivets the eye to the picture's surface and emphasizes its chromatic structure.

Monet neglected his garden, and, besides two paintings of fruit trees in blossom, dating from the spring of 1886, and some peonies painted in 1887, it did not at first occupy a central position in his work. In 1890, however, when the lease on his house at Giverny expired and he was forced to choose between purchasing the house and garden and moving out, he decided to stay put. The decision was an easy one, because he felt sure that he would "never again find such an abode and so beautiful a neighborhood." He was, moreover, gradually becoming more prosperous as a result of artistic recognition both in France and abroad. Monet acquired the property for 22,000 francs, payable in four annual installments. He could now undertake extensive additions and modifications to the house and garden in accordance with his own ideas. His first studio (until 1897) had been situated in the west wing of the house, a former barn rendered accessible from his living quarters by the construction of an interior staircase. Alice had a small blue salon of her own, and Monet's bedroom and the children's rooms were on the second floor. One important, central feature of the house, given Monet's love of entertaining and good food, was the yellow dining room adorned with Japanese woodcuts, for which he designed some color-coordinated china in yellow with a blue rim.

Unlike the dark, overcrowded salons and bourgeois homes around the turn of the century, Monet's décor was simple and countrified. His lifestyle at Giverny was not, however, without its

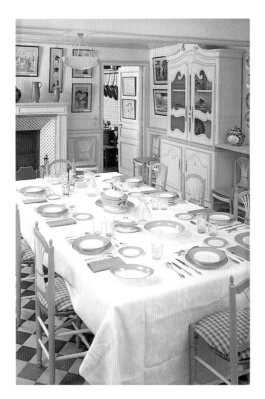

Dining room at Giverny after restoration

bourgeois comforts. He employed six gardeners, a chauffeur, a cook, a washerwoman, and a housemaid. Purchasing an automobile and installing a photographic darkroom, Monet demonstrated that, despite his growing seclusion, he was interested in technical innovations (one of his passions was attending the local motor races). On the other hand, he regarded "Americanization" and the public's continuous exposure to stimuli as a source of cultural impoverishment to which—like the Symbolist poet Charles Baudelaire—he believed the only answer was a return to introspection. As the years went by, Monet became increasingly reluctant to leave his retreat, his "island"; the dinners he gave at Giverny thus took on progressively greater importance. As well as painters like Gustave Caillebotte, Camille Pissarro and Paul Cézanne, and writers, art collectors, actors and singers, Monet's guests included politicians such as Georges Clemenceau,

who in the 1890s became an intimate and faithful friend to the artist and his family.[8] From around 1894 the gatherings at Giverny provided Monet with a substitute for his monthly get-togethers at the Café Riche in Paris and an opportunity to exchange views with painters, writers, and collectors. He kept a close eye on developments in painting, but did not—where Cubism was concerned, for instance—invariably approve of them. He favored the "interior" painters, the Nabis, notably Pierre Bonnard and Edouard Vuillard. Both artists, who were admirers of Monet and guests at Giverny, were directly influenced by Monet's late painting.

Other regular visitors to Giverny included the sculptor Auguste Rodin, the American painter John Singer Sargent, the Symbolist poet Paul Valéry, the Paris art dealers Paul Durand-Ruel and Bernheim-Jeune, Japanese art lovers like the Kuroki family, and Sacha Guitry and his wife, actress Charlotte Lyses.

From 1892, Monet's gardeners and their numerous assistants helped transform what was once a grassy orchard into the luxuriant flower garden of his dreams. Greenhouses were erected for the cultivation of orchids and rare flowers, and many flower beds were dug, some of them exclusively for the irises (see p. 51) that were Monet's clear favorites among the seventy or more varieties in his garden. The flower-fringed central path leading to the south gate was overarched with roses. Having previously kept gardens at Argenteuil and Vétheuil, Monet was able to draw on personal experience to plan a garden that would bloom from spring until late in the fall. He consulted Gustave Caillebotte, who was also an enthusiastic gardener, talked gardener's shop with Octave Mirbeau,[9] and read a great many horticultural publications.

Floral themes were still the exception in Monet's work during the 1890s, though he first painted the waterlily pond on the far side of the railroad track in 1895. He had acquired this plot as an extension to his original garden in February 1893. In the ensuing years the neglected pond and its surroundings—it was

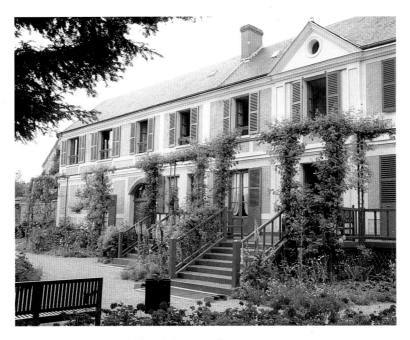

Monet's house at Giverny, 1994

fed by the Ru, an arm of the Seine—underwent considerable modifications directly associated with Monet's waterlily paintings. In order to dam the Ru and maintain a temperature suitable for growing exotic waterlilies, sluices were installed on the east and west sides of the pond. This provoked an outcry among the villagers of Giverny, who feared that these unfamiliar plants imported from the Orient would poison the waters of the Ru, from which their livestock drank and in which they laundered their clothes.

In 1893 Monet also constructed a picturesque humpbacked bridge in the Japanese style over the narrowest part of the pond. First used as a subject for his paintings in the winter of 1895, this bridge reappears in work dating from 1899-1900. The garden was further improved in 1901, the pond enlarged, and the Ru diverted with the permission of the local authorities. The Japanese bridge was surmounted by an additional arch, and the wisteria that grew over it became one of Monet's favorite sub-

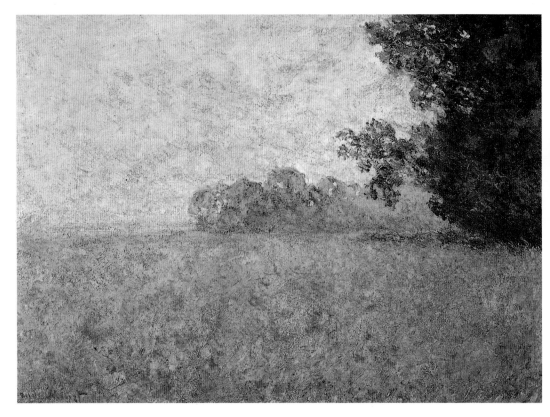

Oat Field with Poppies, 1890

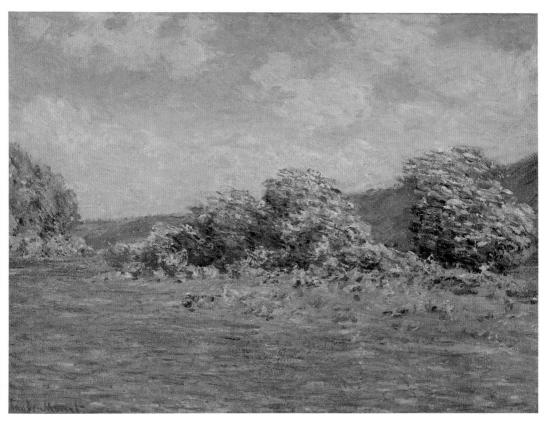

The Seine near Port-Villez, 1890

jects in his late paintings of the bridge (e.g., *Japanese Bridge*) in 1923-25.

In many respects, therefore, the year 1890 marked a turning point. Thereafter, though always on the lookout for new land-scape subjects, Monet traveled less often. On his own admission, he found it increasingly hard to leave Giverny, where he was molding the house and garden to his taste; indeed, when absent from the place he confessed to having "a thing" about it.[10] He was also increasingly prone to rheumatism, which he attributed to his injudicious painting excursions in snowy, frosty, or rainy weather. Having formerly painted a wide variety of subjects, he now concentrated on fewer and fewer. This tendency manifested itself in the pictorial series he painted from 1890 onward, and seriality became the inherent element in his late work. It was in the immediate vicinity of Giverny that, during the 1890s the *Grain Stacks* series, the *Poplars* series (1891), and the *Early Morning* series (1897) originated.

Fascinated with the ever-changing light, Monet painted his first series of *Grain Stacks*, which depicted a traditional Norman method of storing grain by shielding the ears from the elements beneath a layer of hay. Monet recalled noticing a row of such grain stacks while walking across Clos Morin, an adjacent property. He asked his stepdaughter Blanche Hoschedé, whom he had introduced to painting some years earlier, and who often accompanied him on his painting trips, to bring him some canvases.

> When I began I was like the rest, because I thought that two canvases, one for cloudy weather and one for sunshine, would be enough; but soon after I began to record this sunny moment, the light changed, so two canvases were no longer sufficient to capture a faithful impression of nature, if one did not wish to string different impressions together in the same picture.[11]

Thus, a whole series of adjacently placed canvases was needed to record the effects of changing atmospheric conditions between the late summer of 1890 and the winter of 1890-91. When Monet finally reviewed all these canvases in his studio, he felt it was essential to rework them—to bring out their details and coordinate their coloring so that each picture in the series would naturally reflect the previous one and anticipate the next. This involved an entirely different interpretation of reality. According to this, an approximately complete idea of a natural subject can be conveyed only by several different aspects thereof. Although Monet always endeavored to be true to nature, which was his invariable point of departure, imagination was a factor increasingly brought into play by the reworking he undertook in his studio. As he himself wrote of these pictures to Gustave Geffroy, his friend and subsequent biographer:

I have been toiling away at a series of different effects [of grain stacks], but at this time of year the sun sets so quickly that I can't keep up with it.... I'm becoming so slow in my work that I despair. The older I get, the more I see that it takes a great deal of work to succeed in conveying what I'm after: "instantaneity," and, in particular, the atmospheric envelope and the same light diffused over everything. I become more than ever disgusted by things that work at the first attempt. In short, the object of my endeavors is to reproduce what I perceive....[12]

Just as the paintings in this series are roughly the same size, so the changes of viewpoint—whether the artist is painting two grain stacks or one—are insignificant. Their crucial differences consist in the varying light and weather conditions conveyed by their coloring. Of the twenty-five versions of the grain stacks that Monet painted, one shows them on a snowy morning (p. 32), another in late summer (p. 31), and another at sunset (p. 33). He often worked with *contre-jour* effects, so that the outlines of the grain stacks throw long, colored shadows. Their solidity is affected by differing weather conditions and, above all, by changes in the light. They stand out, or recede, or entirely merge with one another. There are also chromatic associations—bright, harmonious, cool, warm—that correspond to the artist's current perception of his subject. Thus the subject appears to be in the throes of a metamorphosis, a permanent state of flux and transformation, evading concrete definition and becoming, as it were, ambiguous. In this respect Monet came close to the Symbolist views of his friend, the poet Stéphane Mallarmé, who held that real objects cannot be firmly defined but only approximately described. Monet's conception of the natural world had a metaphysical basis. He explained it to Georges Clemenceau as follows:

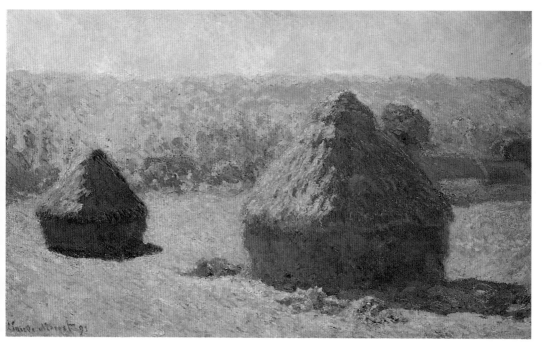

Grain Stacks, Late Summer, 1891

The rest of you inquire into the world as such, whereas I concentrate my endeavors simply on as many different manifestations as possible in their relationship to unknown realities. When one is in harmony with those manifestations, one cannot be very far removed from reality, or at least from as much as we can perceive of it. All that I have ever observed is what the world has rendered visible to me, so as to testify to it with my painting.... Your mistake is to try to reduce the world to your own dimensions, although a growing knowledge of things should surely increase your self-awareness as well.[13]

In this sense, Monet's painting thenceforth ceased to be a mere reflection of life and—in approximation to the Symbolist view of the limits of reality—opened up visionary areas.

The year 1890 therefore marked a change in the very character of Monet's work, because from then on he steadfastly pur-

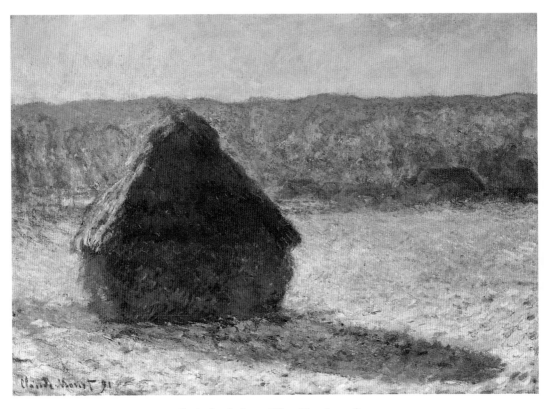

Grain Stack, Snow Effect, Morning, 1891

sued the idea of painting several pictures of the same subject. Series painting presupposes a conscious decision, either before starting work or while work is in progress, to paint the same or a closely related subject from a limited number of viewpoints and in a limited number of formats. For purposes of tonal co-ordination, each work shares colors and "*effet*" with other pic-tures in the series, so that a series of individual works is always governed by their totality, by the sight of all of them taken to-gether. This being so, the individual paintings can be completed only when viewed side by side in the studio. For Monet the paint-ing and completion of pictures outdoors, the *plein air* method peculiar to Impressionism (particularly in the 1870s), had

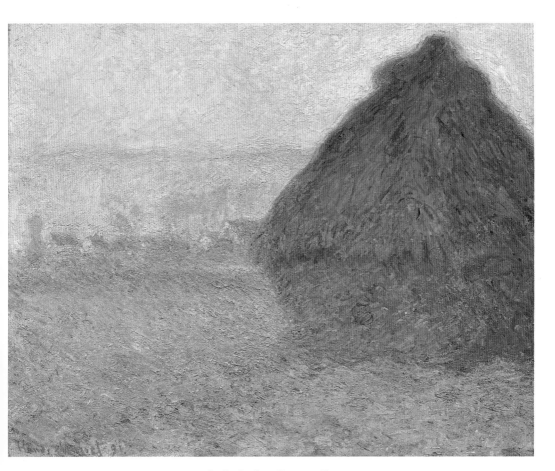

Grain Stack at Sunset, 1891

ceased to matter. The same naturally applied to his interest in topography, which had been dwindling since the 1880s. As subject matter became secondary, color, light, and structure acquired pictorial salience. Monet's new artistic approach did not meet with unanimous approval—indeed, Camille Pissarro accused him of having taken to painting series out of cupidity.

Inspiration to adopt serial methods of painting also came to Monet through the works of Japanese woodcut artists, among them Hokusai's *Hundred Views of Mount Fuji* and Hiroshige's *Hundred Views of Edo*, which he saw at Samuel Bing's Paris gallery in 1888 and at the Exposition Universelle in 1889. He also owned a sizable collection of colored woodcuts by Hokusai, Hiroshige, and Utamaro, some of which hung in his dining room at Giverny (see p. 35).[14] Further contacts with the Japanese art world arose from his friendly relations with Japanese collectors and dealers such as Tadamasa Hayashi and Kojiro Matsukata, who in turn admired his work and introduced it into their own country. The idea of painting several views of the same subject was not, therefore, an innovation.

Monet himself had previously employed this method in 1877, in his paintings of the Gare Saint-Lazare, but his recurrent interest in the theme of reflections, which dated from the late 1860s, was another subtle pointer in the same direction. After the *Grain Stacks* series, this method of working became associated with the increasingly close-up views and growing reduction that culminated in his late waterlily paintings. Although, being a quasi-scientific procedure, series painting accorded with contemporary mathematical theories, any kind of theorizing was wholly alien to Monet. With him, the series resulted from close observation of the natural world, the recording of characteristic moments in time, and the growing importance of his artistic resources. Series painting also expresses an altered perception of reality in which the crucial factor is change, that is to say, movement, but also the enduring, all-uniting element that Monet termed the "*enveloppe.*" In conceiving of kinetic matter, Monet was

Hokusai, Mount Fuji Seen through the Piers of Mannenbashi,
ca. 1831

almost intuitively espousing the views of contemporary scientists and philosophers, and, in particular, the Vitalist philosophy of Henri Bergson.[15] Bergson held that the totality and harmony of all life forces in the past (memory) possess a common origin from which evolves the *élan vital*, the creative force inherent in nature. If human beings cast off their intellectual incrustations and through intuition merge anew with that totality, they can immerse themselves in pure, continuous, enduring time.

Against this background, it becomes clear why serial artistic idioms can also be discerned in poetry and music around the turn of the century.[16] Thus, Monet's pictorial series may justly be compared to Marcel Proust's cyclical novel in fifteen volumes, *Remembrance of Things Past* (1913-27), because there, too, the real theme is not a linear succession of occurrences but the juxtaposition of many different temporal planes. As in Proust, and so in Monet, the fundamental theme is the way perception alters with the passage of time. For Monet, only this can conjure up a characteristic natural state. The flow of time is recorded

on the surface of the canvas instead of by topographical observation and the structure of things.

The *Grain Stacks* series was important not only from the aspect of the serial method that Monet consistently employed thereafter, but because of the more abstract treatment of his subject matter. In May 1891 Durand-Ruel showed in his Paris gallery fifteen of the *Grain Stacks* paintings as a self-contained series. The exhibition was a great success, all the works being sold within a few days. Discounting a few critical voices, the response, even from young, avant-garde artists like Piet Mondrian, André Derain, and Maurice Vlaminck, was euphoric. Wassily Kandinsky, who saw one of these paintings at an exhibition in Moscow in 1895, described it as being the first of Monet's nonrepresentational works:

And suddenly, for the first time, I saw a picture. The catalogue informed me that it was a haystack, but I couldn't make it out.... I vaguely felt that this picture lacked a subject.... What I did clearly perceive was the unsuspected strength of the palette, which had hitherto escaped me....[17]

From this point on, Monet won artistic recognition both in national and international circles. Droves of young artists, many of them from America, settled in Giverny in order to paint in close proximity to the artist they admired—an influx of which Monet often complained. Of these numerous American painters, Theodore Robinson was privileged to go painting with Monet, and Theodore Butler actually became a member of the family by marrying Suzanne Hoschedé-Monet. John Singer Sargent was another frequent visitor. Attracted by the one-man exhibitions organized by Durand-Ruel in New York in 1891 and Boston in 1892, wealthy American collectors also started to descend on the village.

His new-found financial success enabled Monet to buy and redevelop the house and garden at Giverny. After having estab-

Alice Monet-Hoschedé, Monet's second wife, ca. 1900

lished his permanent residence here, he legalized his relation-
ship with Alice Hoschedé. She was responsible for day-to-day
matters, including the organization of the dinners, which were
now more frequent and had assumed even greater importance
as Monet's absences from home grew steadily rarer. Conversa-
tion at these gatherings did not center on art and politics alone,
but extended to more banal subjects as well, such as gardening
and cooking. An unashamed hedonist who ate and drank with
gusto and smoked like a chimney, Monet was an enthusiastic
collector and swapper of recipes, though he left their prepara-
tion to his cook.[18]

In the fall of 1891, in line with his growing artistic preoccupation with Giverny and its immediate surroundings, Monet embarked on a series of twenty-three paintings of poplars on the right bank of the Epte near Limetz (see map on p. 14). Shortly after deciding on this subject, he learned that the local authorities had given permission for the trees to be auctioned. When his requests for a postponement failed, he got in touch with the likely purchaser, a timber merchant, and offered to make up any difference between the sum the man was prepared to bid and the price the trees actually fetched at auction, provided they were not felled until he, Monet, had finished painting them. This time he was successful. Seated aboard his floating studio, he painted the poplars not only from a considerable distance, as a regular, diagonal row, but from directly opposite and close at hand. He reverted to the theme of reflection that had often recurred in his work since the late 1860s; however, the distinction between reality, the surrounding countryside, and its mirror image gradually became less clear. By the vertical trunks of the poplars that dissect their surface, these paintings convey a "spaceless" impression, in the traditional sense. Their two-dimensional stratification, in which the latticework of the trees alone conveys an idea of the landscape beyond, is much more reminiscent of Japanese woodcuts, and also of works by van Gogh (e.g., *View of Arles*, 1889; Neue Pinakothek, Munich). It becomes clear that in these poplar paintings compositional elements such as horizontals and verticals, when contrasted with the diagonal momentum of the S-shaped row of trees in the background, serve as mere anchors in a painting in which color is the fundamental factor. Complementary pairs of colors such as bluish violet and yellowish orange, applied in small dots, atmospherically convey the shimmering, all-pervading light of a sunny day in the fall (p. 39) or the rich, dark coloration of an

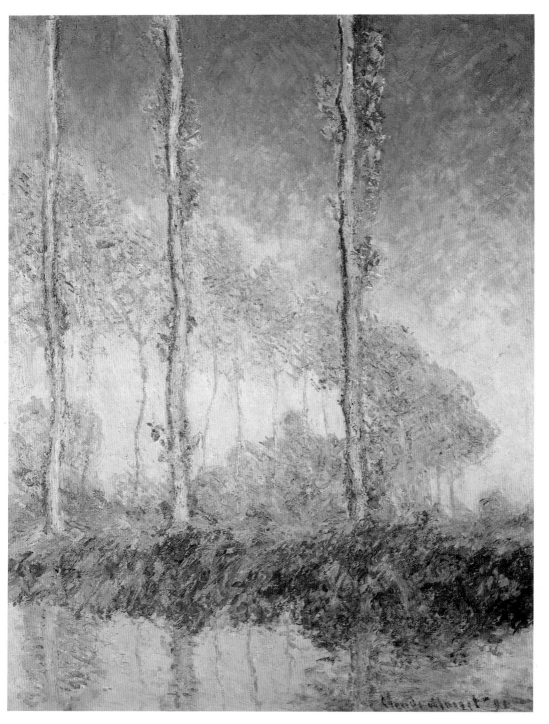

The Poplars, Three Trees, Fall, 1891

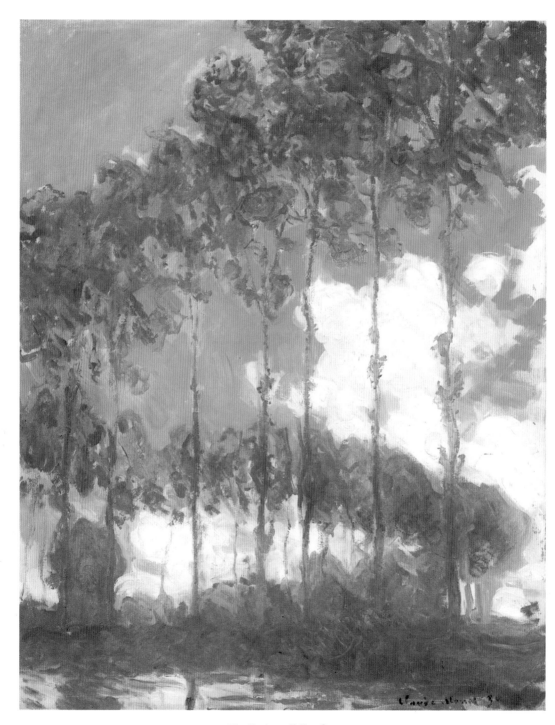

The Poplars, Fall, 1891

overcast day at the same time of year (p. 40). From the aspect of overall harmony, strong chromatic contrasts of the kind that strike the eye in works painted at Antibes (1888) and Bordighera (1884) meld into one field of color in this series. Monet was now making greater use of chromatic harmonies and finely coordinated series of colors. These, together with the strikingly decorative, linear, two-dimensional factor, almost prefigure Art Nouveau. Like the *Grain Stacks* series before them, *Poplars*, fifteen of which Durand-Ruel put on public exhibition in March 1892, enjoyed an immense success.

Monet's growing predilection for a form of painting that had ceased to portray reality in the naturalistic sense and gave thematic precedence to subjective memories and emotions is attested by his repeated visits to places like Pourville, Dieppe, and Varengville, where he had painted years earlier. He wanted, he said, to make a present approach to past subjects and sensations and submit them to empathetic reexamination. This rang the changes on certain basic features of the serial method, because Monet's revisiting of the above places may be likened to a resumption of work on related subjects. In this sense, a relationship exists between the ice-floe pictures that originated in 1893 at Bennecourt, near Giverny, and the ice-floe pictures on which Monet had worked at Vétheuil in 1880, after the death of his first wife, because they were doubtless in thematic harmony with his state of mind. The works dating from 1880 (e.g., *The Ice Floes*; p. 43), depict the Seine and its banks from a kind of wide-angle perspective that conveys a strong impression of depth. *Morning Haze: The Ice Floe* (1894; p. 42) differs entirely in that it looks across the ice-littered Seine at the opposite bank, which becomes the horizontal axis of a central reflection. The ice-floes that seem to hover—not float—on the surface of the water, and by the "*enveloppe*," the diffuse, all-enveloping coloration, dissolves outlines and binds everything together. Monet managed to convey the unity of the whole and its unifying element by capturing the effect of diffused light, because his shapes appear

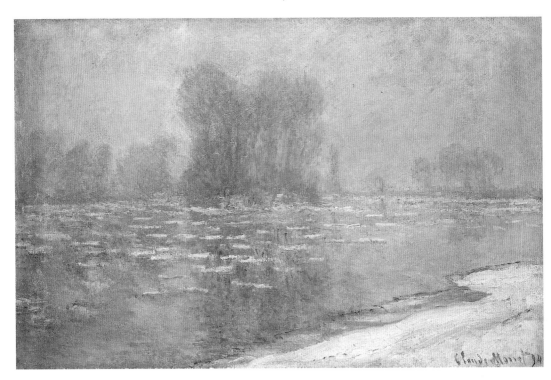

Morning Haze: The Ice Floe, 1894

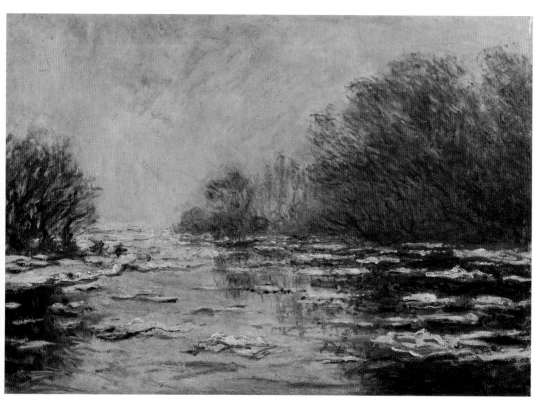

The Ice Floes, 1880

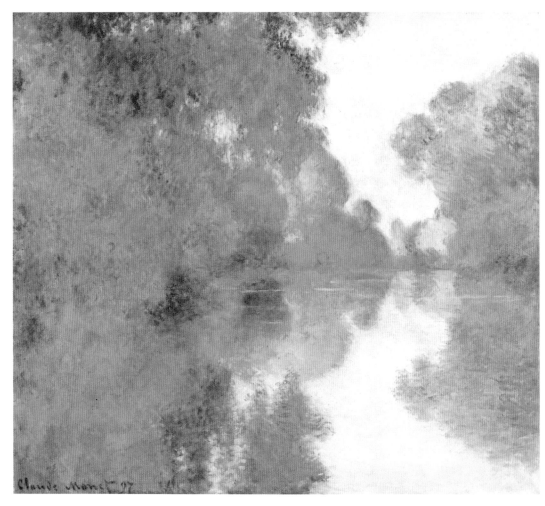

Early Morning on the Seine, 1897

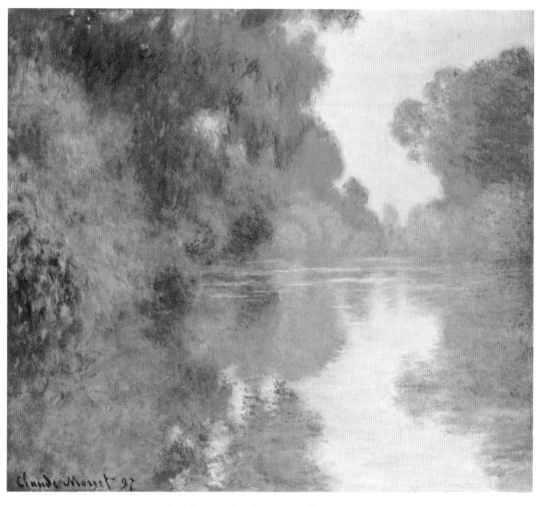

A Tributary of the Seine near Giverny, 1897

blurred and ill-defined. In this sense Eugène Delacroix, too, favored the halftone as a means of reproducing the color of things in diffused light. In Monet's case, as in Delacroix's, this technique stemmed from his observation of nature, which had taught him the atmospheric connection between things, and from his perception of life as all-embracing mobility.

In 1896-97 Monet took another step in this direction with his *Early Morning on the Seine* series (see pp. 44-45). Though not far short of sixty, he maintained a strict daily routine that got him out of bed long before sunrise during the summer months. Only thus could he capture those moments at dawn when the sky became tinged with pink and the river was still wreathed in mist. Misty scenes and intangible, atmospheric effects were a frequent preoccupation of Monet's during the 1890s (see *The Church of Vernon in the Mist;* p. 47), but the paintings in this series are always governed by a single atmospheric note. The broken brushstrokes particularly discernible in Monet's Impressionist works of the 1870s had been abandoned in favor of homogeneous brushwork that binds all things together and lends them equal value. The American painter Lilla Cabot recorded the following statement that Monet made during one of her visits to Giverny: "When you go out to paint, try to forget what objects you have before you, a tree, a house, a field or whatever [...] Remember that every leaf on the tree is as important as the features of your model."[19] Monet's words reflect the romantic conception of a universal harmony in which the world was seen as an organically developed and constructed whole, so that observations of scenery became an observation of oneself. Experience of nature thus became something new: an experience of nature from within Nature, as the Symbolist poet Charles Baudelaire believed, supplied the material, the "symbol," that enabled the artist to express his innermost self.

Landscape painting of this kind could also be construed as an attack on the current conception of nature, on the prevailing order and traditional patterns of perception. The pure land-

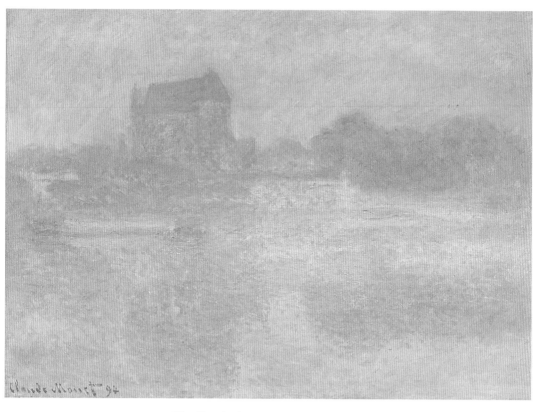

The Church of Vernon in the Mist, 1894

scape painting of the Impressionists and the pre-Impressionists of the Barbizon School had jettisoned the ballast of academic scholarship. The official artistic doctrine of the nineteenth century regarded this as downright dangerous because it granted excessive freedom to the artist's subjectivity and imagination. Composed in accordance with rigid, ideal rules, academic landscape paintings were often intellectually embellished with allusions of an allegorical, mythological, or historical nature. They thus appealed mainly to a highly educated public, whereas pure landscape paintings were accessible to ordinary folk and became very popular with a growing section of the middle class during the latter half of the nineteenth century. The artists of the Barbizon School were direct precursors of the Impressionists. In 1830

or thereabouts, mindful of the achievements of the bourgeois Dutch landscape painters of the seventeenth century, they broke away from the official, classical Italian form of landscape painting and applied themselves to subjects drawn from direct, personal observations of the natural world. Because they inevitably had to contend with changing atmospheric conditions, light and color became crucial factors in their painting. Monet was decisively influenced by representatives of this school, including Charles-François Daubigny, Camille Corot, and, to cast the net somewhat wider, Eugène Boudin and Johan Barthold Jongkind.

The sense of repose and immobility conveyed by the pictures in the *Early Morning* series is heightened by their almost square format. Water, light, and reflection become governing factors, thus foreshadowing the waterlily pictures. The distinction between reflection and reality, actuality and illusion, gradually disintegrates. In his late works, Monet sought a solution to a fundamental problem: how to preserve a reference to nature in face of the growing importance of imagination. He elaborated and completed these paintings from 1897 on in his new studio, which was housed in a building specially constructed for the purpose (see map on p. 15). Already seventeen of the series were shown at Durand-Ruel's gallery in 1898, and, like the series that preceded them, were a resounding success.

Impressionistic painting had prevailed at last—and this despite Emile Zola's novel *L'Œuvre*, published in 1896, a withering attack on Impressionism and its representatives. Monet and several other Impressionists, notably Paul Cézanne, thought that they recognized themselves in the book's protagonist, a painter named Claude Lantier, and Cézanne promptly severed relations with the author. Zola rose in Monet's estimation, if only briefly, during the Dreyfus affair in 1897-98, when he came out in support of the Jewish army officer Alfred Dreyfus on the ground that his indictment for high treason had been motivated by anti-Semitic prejudice—a view that Monet shared.

The ensuing years brought turbulence and changes in the family domain as well. In 1897, after some initial opposition from his father, Monet's son Jean married his stepsister Blanche Hoschedé-Monet and moved with her to Rouen. Blanche did not return to Giverny until 1914, after Jean's death. Monet was profoundly saddened by the loss of two close friends in quick succession, Stéphane Mallarmé, the Symbolist poet, and shortly thereafter the Impressionist painter Alfred Sisley, both of whom died in 1898, and by the death of his stepdaughter, Suzanne Hoschedé-Butler, in the spring of 1899. The loss of her daughter subjected Alice to severe bouts of depression from which she never recovered. Nothing could shake them off, not even the trips to Venice and Madrid that she and her husband made in their newly acquired automobile. Monet himself suffered increasingly from rheumatism and a worsening eye condition that had troubled him since 1867 and that eventually, in the 1920s, rendered it necessary to operate. He took all the more pleasure in the walks in his garden, which brought him peace of mind and inward serenity.

The garden (see pp. 51-53), and the water garden in particular, became his favorite subjects from then on. When visiting Giverny in 1897, art critic Maurice Guillemot[20] saw several large views of the waterlilies that were intended for a decoration (then unidentified). Thus the garden extension of 1901-2 was directly associated with Monet's plan to create a permanently installed decoration consisting of pictures of a lily pond. These would include views not only of the surface of the pond and its surroundings but also of the bridge that spanned it. Meticulously laid out in accordance with Monet's own designs, by which the colors and shapes of the plants growing there were coordinated, the garden steadily developed into a work of art in its own right. It was one gardener's full-time job to maintain the waterlilies as Monet wanted, from a compositional point of view. This skillfully laid out, self-contained water garden, with its waterlilies and Japanese bridge, its waterside willows and poplars, its irises, agapanthus lilies, and roses, became the dominant pictorial subject, which Monet described as follows in a letter to the art critic Roger Marx:

> It is a pond which I laid out fifteen years ago. Some 200 meters long, this pond is fed by a lateral arm of the river Epte. It is surrounded by irises and various aquatic plants and framed by various trees of which poplars and willows, including several weeping willows, predominate.[21]

Monet had already painted the Japanese bridge in 1895 and 1897, but he did not tackle it as a coherent series until 1899-1900. Entitled *Harmony in Green* (p. 54), this was shown by Durand-Ruel in 1900. It depicts a frontal view of the bridge facing west from the waterlily pond. The pond's surface in the foreground, covered with waterlilies in bloom, is spanned by the

Bed of Irises in Monet's Garden, 1900

gentle curve of the bridge, whose framework is the only structural element. In the background, the luxuriant vegetation—including poplars and willows—grows on the grassy banks and is harmoniously reflected in the water's surface. The lily-covered water and surrounding greenery and their reflections are largely interwoven by the skill of Monet's free, homogeneous brushwork. As the entire canvas is taken up with water and vegetation, there is no direct view of the sky. But, though it is not directly visible, it becomes part of the subject by virtue of reflected sunlight and bizarre cloud formations. Thus, Monet's excerpt from nature succeeds in conveying a complete idea of it. These excerpts, which varied only in mood and coloration, were then regarded as most unusual, and contemporary critics regretted that the Japanese bridge series displayed so little variation and was painted from an almost unchanging viewpoint.

The rather strict symmetry of the 1899 pictures was succeeded one year later by works in which Monet used stronger color contrasts and chiaroscuro effects. He also brought the left-hand bank into greater play, thereby revealing the sky. The bridge pictures underwent their final reworking in the studio, so their

Main path in Monet's garden, 1994

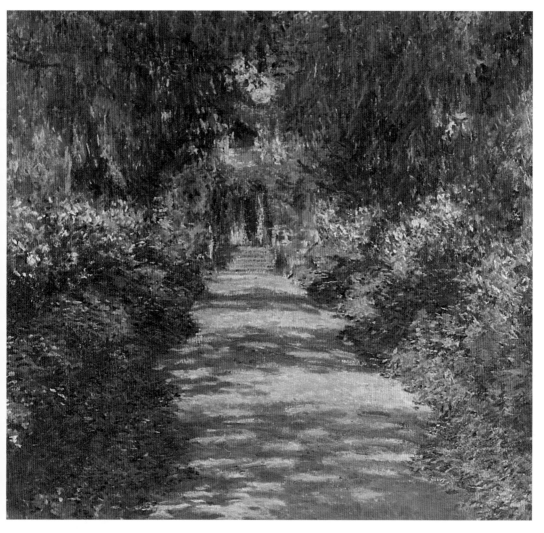

Path in Monet's Garden, 1901-2

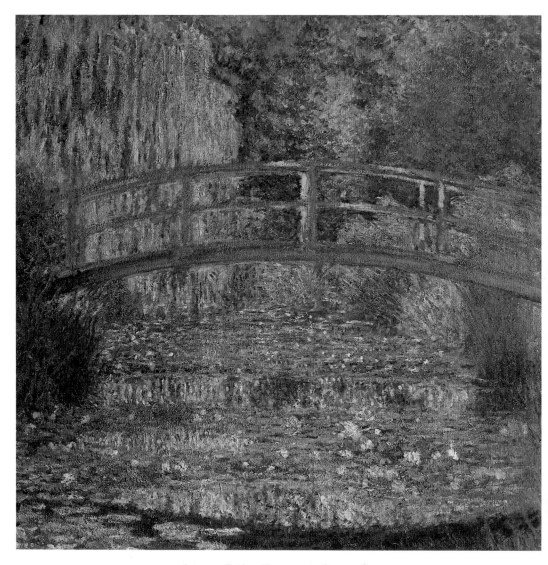

Japanese Bridge, Harmony in Green, 1899

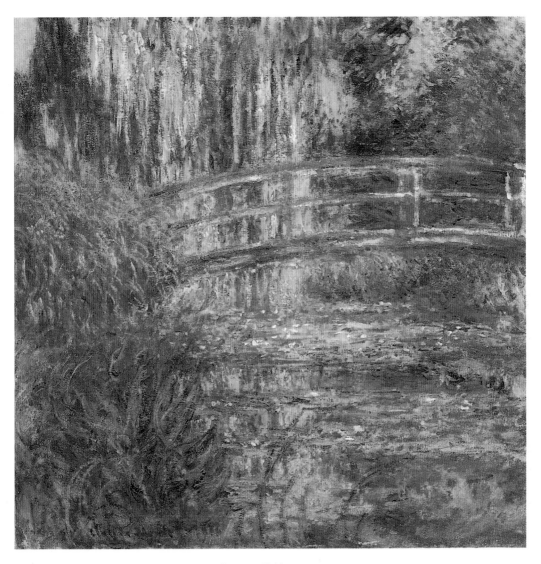

Japanese Bridge, 1900

varying perceptions are once more based on Monet's recollections of what he actually observed, for instance in the morning or evening. The importance of color coordination to these individual pictures, which are additionally harmonized by their almost square format, is attested by titles such as *Harmony in Green* (p. 54). Monet often regretted, for this reason among others, that his series had to be broken up for commercial purposes, and Clemenceau tried in vain to arrange a government purchase of his *Rouen Cathedral* series. As early as 1897, therefore, Monet evolved a plan to decorate a room with waterlily pictures. In 1909 Monet contemplated producing a series of canvases for a dining room. Interior decorations with floral themes had been familiar to him at latest since he produced some for the Hoschedé family's living rooms at Montgeron (1876) and for Durand-Ruel. In addition to other contemporary interior decorations of this kind, he was naturally acquainted with Gustave Caillebotte's dining room at Petit-Gennevilliers (1894), which probably came closest to his own ideas. Interior decorations acquired growing importance for artists around the turn of the century. Set against a background of industrializa-

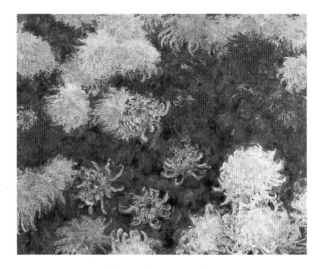

Chrysanthemums, 1897

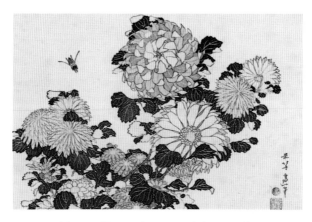

Hokusai, Chrysanthemum and Bee, ca. 1832

tion, alienation, and incessant subjection to stimuli, they provided oases of peaceful contemplation in which the lost ideal of humanity's union with nature could restore itself. As portrayals of idyllic inviolacy, garden scenes were particularly suitable for this purpose.

Like the contemporary *Chrysanthemums* (p. 56), the first waterlily paintings, which date from around 1897, display an entirely new kind of detail. Monet was partly inspired to tackle this subject by Hokusai's woodcut entitled *Chrysanthemum and Bee* (above), which he had owned since 1896. The chrysanthemums, painted in close-up, float on the surface of the canvas like the lily pads and blossoms on the spatially undefined surface of the water. Monet concentrated his gaze on a specific section of the pond, so that the surrounding scenery and the vegetation on the banks are either excluded altogether or merely suggested, for instance by trailing branches (as in *Waterlilies*, 1903; p. 58) or as a narrow border in the upper part of the picture (as in *Waterlilies*, 1904; p. 61). In this manner, they offer the viewer another aid to spatial orientation. Whereas in 1903 Monet had favored a more elongated or traditional format, in 1904 he reverted to square canvases. Not only in 1903-4 but also in 1905 and 1908, different compositional types or series of waterlily pictures can be distinguished, as Monet painted from

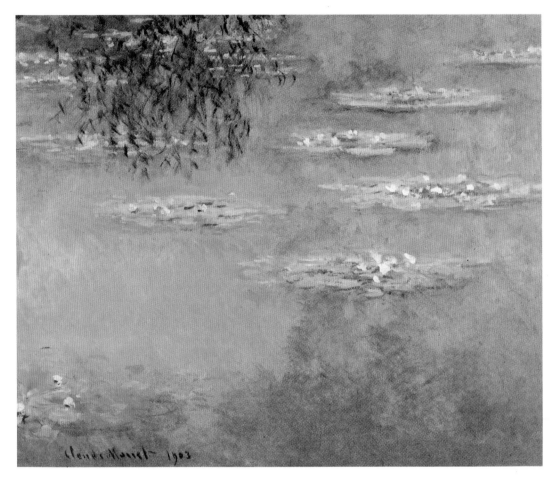

Waterlilies, 1903

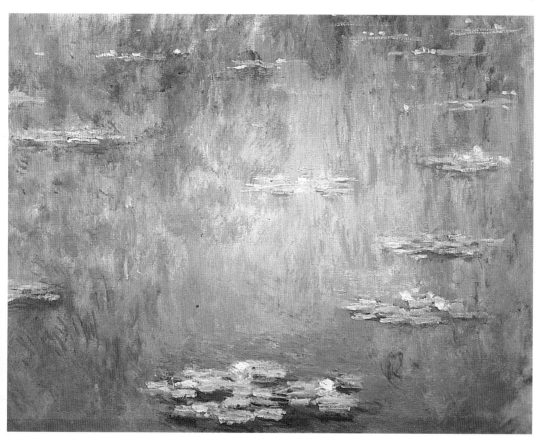

Waterlilies, 1903-4

Page 61: Waterlilies, 1904 (detail)

varying viewpoints. A vivid impression of the contemporary ap-
pearance of Monet's garden is conveyed by some photographs
of the water garden taken by the art critic Louis Vauxcelles while
visiting Giverny in 1905 and published for the first time that
same year (p. 64).[22] These photographs, along with individual
paintings of this period, attest to the addition of the Japanese
bridge's metal handrails, which in years to come would become
overgrown with wisteria. Although the 1905 paintings show the
water garden from various angles, in 1906 Monet painted from
one position only. As in the works dating from 1897, the land-
scape here becomes a purely reflected one. The scenery, trees,
plants, sky, and clouds surrounding the pool appear only as re-
flections on the surface of the lily-covered water. Water and can-
vas coincide. Traditional aids to orientation such as above (sky)
and below (water), front and back, are rendered as indetermi-
nate. Even chromatic classifications of the natural and reflected
realities are no longer discernable. To the contemporary eye
this created the impression of a *"tableau renversé,"* or inverted
picture.[23]

Monet adopted the same procedure in the 1907 examples of
his work (pp. 63, 67), which were printed from two different
viewpoints. Compared to the paintings of 1903-6, the vertical
examples are of special interest. Predominant here are strongly
accentuated light and color contrasts of the kind Monet could
observe on the surface of the water during the evening hours.
Like half-drawn curtains, the dark reflections of the trees that
flank the picture immediately draw the eye to the spectacle cre-
ated on the surface of the water by the sunlight's warm, bright
radiance. Chiaroscuro contrasts divide the picture into areas
that are warm and bright, dark and luminous, cool and shady;
and the light zone, partly because of its thicker impasto, devel-
ops an inherent dynamic that seems to attract the eye in a singu-
lar manner. Suggested by a few abstractive brushstrokes, the oval
shapes of the lily pads float across the entire canvas, diagonally
dwindling in size to convey spatiality. The coloring complies with

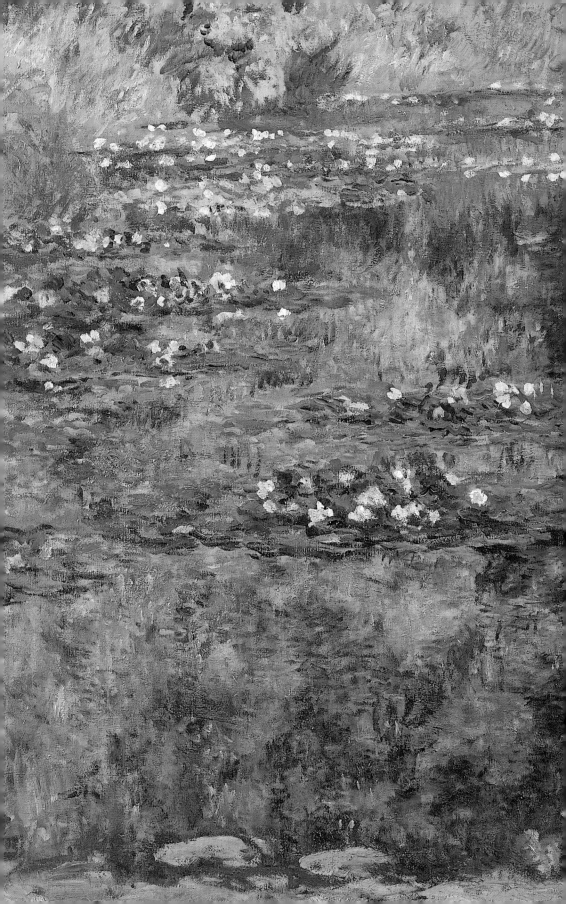

associations governed by visual experience, but it is not definitely or concretely objective. Although related to reality, color and form attain a large measure of autonomy. The homogeneous, consistent structure and unifying brushwork make it hard to distinguish between the expanse of water, the reflections of the surrounding scenery, and the weeds and plants below the surface. This amalgamates the foreground, middle ground, and background. The simultaneous perception of reality and its reflection leads to an extension of space, a new spatiality.

Monet's water garden paintings are horizonless landscapes in which traditional ideas of space are exploded and space itself expands. On the formal plane, this spatial expansion was consistent with Monet's intention to leave his waterlily pictures unframed, to use large, wide canvases, and allow the shapes of the waterlilies themselves to overrun the edges of the paintings. In short, that intention accorded with the whole plan underlying the series, in which each picture was to form part of a continuum. Because of the constant alternation of levels of meaning between reality and reflection, solidification and dissolution, the time factor becomes another sustaining pictorial element. The conception of an open-ended space-time continuum links the individual pictures with the scheme of the series and reveals Monet—with his aesthetic of open form—as being a leading figure of modern painting.

Monet seems to have had a particular liking for this pictorial conception of 1907 as he also re-adopted it later in his wide-format waterlily decoration for the Orangerie, as for instance in *Waterlilies in the Evening* (see pp. 94-95). Many of the diverse pictorial compositions of 1903-9 were absorbed into the large-format waterlily decoration in the Orangerie, so they belong in the same context. Although Monet worked on these water-garden landscapes with all his might, there were repeated interruptions during which, plagued by doubts and impelled by his own striving for perfection, he questioned or even destroyed what he had already done. "These 'water and reflection land-

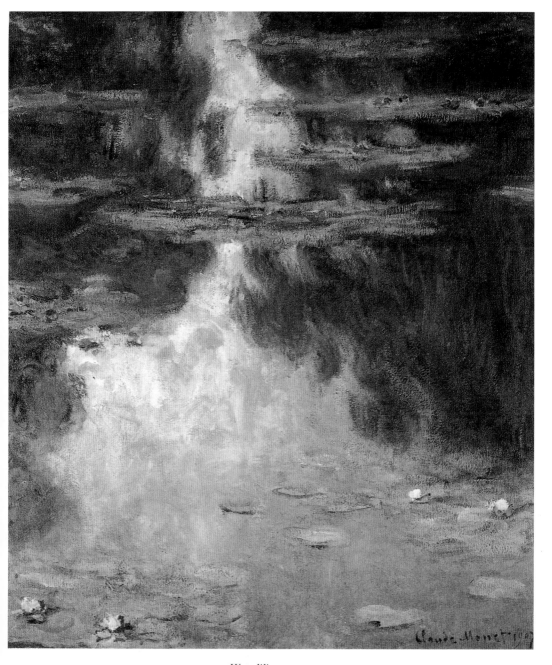

Waterlilies, 1907

View of the waterlily pond and the Japanese bridge, 1905

scapes' have become an obsession," he wrote to Gustave Geffroy in 1908. "They're too much for an old man's strength, yet I should like to be able to reproduce what I feel. I have destroyed several of them.... I am beginning afresh ... and hope that something will come of so many endeavors...."[24] As in all the preceding years and decades, Monet subjected himself to a strict daily routine: "In fine weather I work in the mornings from seven to eleven ... and after lunch from one to three. Then comes a rest until six."[25]

When Durand-Ruel showed forty-eight waterlily pictures (pp. 58, 61, 67) in May-June 1909, Monet insisted that they be hung in chronological order. This exhibition, for which plans had originally been laid in 1907, was accompanied by one or two difficulties. Monet, who had recurrent misgivings about it, kept putting the dealer off. His mood alternated between confidence and profound self-doubt:

I'm very dissatisfied with myself, but that's better than producing things that are mediocre. I'm not postponing this show because I want to exhibit as many pictures as possible. On the contrary, I feel I have too few works worthy of being shown to the public. I have five or six at most that merit consideration, and have just, to my great satisfaction, destroyed at least thirty.... As time goes by I recognize those pictures that are good and those that should not be kept. But that doesn't prevent me—far from it—from doing better ones, filled with enthusiasm and confidence.[26]

Durand-Ruel's reaction to a preview of these unusual landscapes had been very cool, so Monet, for safety's sake, insisted that the dealer make a firm undertaking to purchase some of them. In the event, the show proved to be such an overwhelming success and drew such crowds that it had to be extended for a week. Since all the works were hung in one room, Monet's serial conception, the idea of an inherent link between them,

was particularly manifest. According to art critic Arsène Alexandre, Monet had always regarded these waterlily pictures as an integral whole while reworking them in his studio, and had kept them set up in a row there for six long years.[27] At the same time, he revived his old plan to adorn a circular room with such paintings, so that the beholder would be surrounded at eye-level by a continuous expanse of water and flowers. In the course of a conversation reconstructed by art critic Roger Marx, Monet expressed himself on the subject as follows:

> I was once tempted to use this waterlilies theme for the decoration of a salon: extending along the walls, they were to convey a unitary impression, the illusion of an endless whole, a wave devoid of skyline and shore.... This room would provide a refuge for undisturbed meditation in the midst of a blossoming aquarium.[28]

Although this plan did not come to fruition until years later, in the *Waterlily Decoration* at the Paris Orangerie, the show of 1909 paved the way for it. Various types of composition represented at that show were incorporated as parts, mainly central parts, in the Orangerie's far larger canvases, so that the latter appears to present a synthesis of various solutions to the water-garden landscape theme.

Between 1909 and 1914, however, this subject temporarily fell into abeyance. Until 1912 Monet devoted much time to elaborating the views of Venice on which he had embarked in 1908. His first trip to Venice undertaken with Alice in the fall of that year was followed in 1909 by another visit, although he completed the Venice paintings from memory, while working in his studio, between 1908 and 1912. Another problem was that, in January and February 1910, his garden had been devastated by

Waterlilies, 1907 (unfinished)

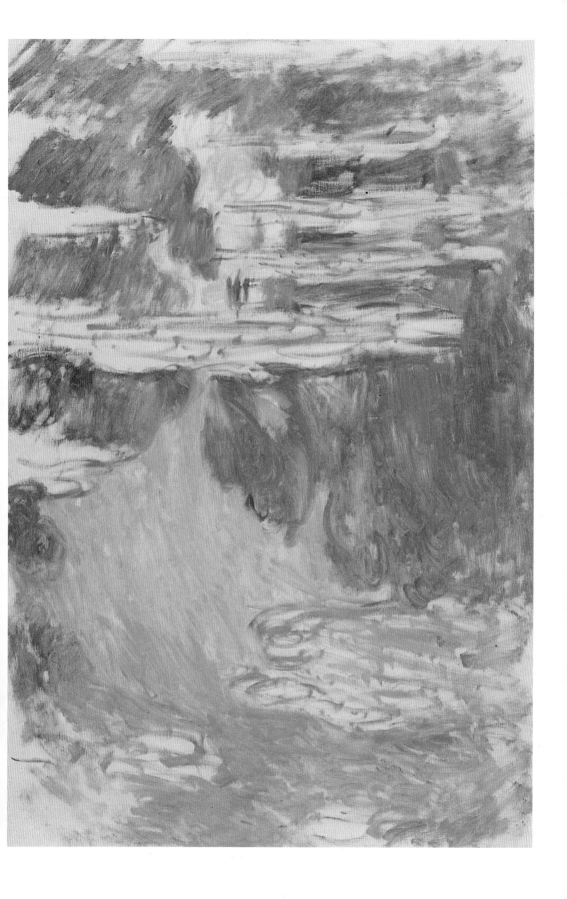

severe flooding, so there was no possibility of painting there. The garden path was under water, the pond burst its banks, and the aquatic plants were swept away. Monet was unhappy and preoccupied with a single thought, namely, how to restore his flooded, mud-covered garden. Alice's death in May 1911 was another shattering blow. Painting now became his only consolation, but in 1912 his morale reached a new low when failing eyesight compelled him to consult a specialist in Paris. Monet feared that, like Edgar Degas, who was virtually blind for the last twenty years of his life, he would have to give up painting altogether. The ophthalmologist diagnosed cataract in both eyes and recommended surgery, which Monet at first refused. It was not until 1923, when his eyesight had deteriorated still further, that he finally gave in; however, the operation was not a resounding success. Half blind, he complained to friends and visitors about the effects of his ailment—that he often used unduly dark colors, for instance, and had sometimes to be guided by the labels on the tubes of oil paint. In 1913, although his eyesight had been improved by some specially made glasses, he wrote despairingly to Durand-Ruel that he had given up hope of producing any more good work.

Such was his state of mind when, in February 1914, he heard that his eldest son Jean had died. Blanche Hoschedé-Monet now returned to Giverny, where she self-sacrificingly devoted herself to the artist's welfare—in fact Clemenceau christened her "the white angel." It was Blanche's and Clemenceau's unremitting care and, more especially, steadfast moral support that prompted Monet, despite everything, to address himself to the waterlily decoration in his last years.[29] By the summer of 1914, when the waterlilies were in bloom, he was eager for the fray. "I've gone back to work," he informed Durand-Ruel, "and, as you know, when I do that I do so seriously. I get up at four, toil away all day long, and when evening comes I'm overcome with fatigue.... My eyesight is good at last. Thanks to work, my true consolation, all is going well."[30]

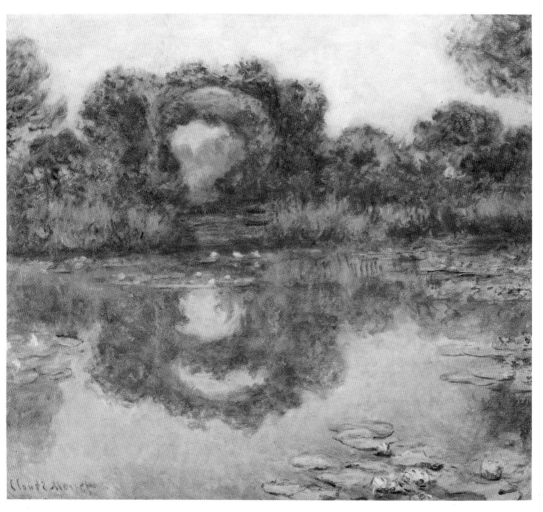

Arc of Roses, 1913

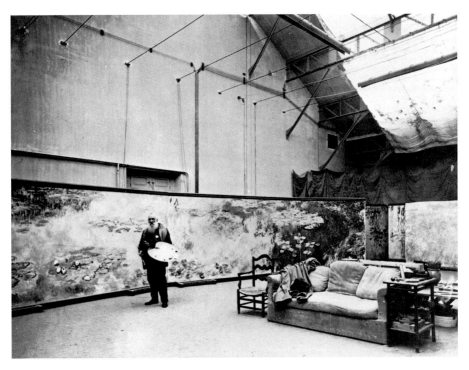

Monet in his studio with waterlily decoration for the Orangerie, 1917

When Geffroy visited Giverny not long afterward, Monet showed him some wide-format waterlily pictures that represented the beginnings of his monumental *Decoration*. Concentrated work on these paintings provided a source of solace and distraction in the turmoil of war. In 1915, having by then resorted to canvases of increasing size, which he planned to complete in his studio in the winter, Monet had a new studio erected on the east side of the garden (see map on p. 15); 78 feet long and almost 40 feet wide, this was specially built to accommodate the waterlilies. Because of wartime shortages, Monet was often dependent on the help of Etienne Clémentel, the Minister for Economic Affairs, who was a friend of his. It was only thanks to Clémentel that Monet managed to obtain sufficient building materials and oil for paints, get canvases transported to or from

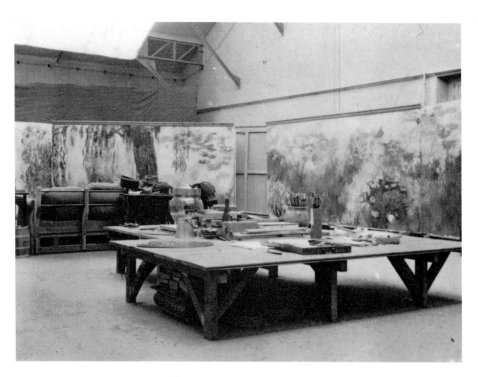

Monet's waterlily studio, 1917

Paris, and prevent his car from being requisitioned. By the summer of 1915 Monet was able to play host to his friends from the Académie Goncourt, an exclusive writer's association to which Octave Mirbeau belonged, and show them not only the new studio under construction but a group of waterlily paintings between 10 and 16 feet wide.[31] The waterlily studio was finished in November 1915, though Monet thought it exceedingly ugly and was never altogether satisfied with it. Partly because of the waterlily paintings' dimensions, less and less of the initial work was done outdoors. Monet dispensed entirely with preliminary drawings of the kind he had sometimes done up to 1890. All his canvases were now primed in white, and the first working session was devoted to establishing the tonalities, the light and shade values, in thin layers of paint freely applied. Before build-

ing up these tonalities further, sometimes by leaving the interior shapes blank (see p. 67), Monet would apply textures with broad brushstrokes. These textures varied in direction, shape, size, and coloration, according to what they represented, and served to counter the amorphous "flowing apart" of colors that Monet criticized in Turner's work. In the course of twenty to thirty or more sessions, Monet applied several layers of dry impasto (seldom wet on wet) from which the oil had previously been removed. The brushstrokes were only partly superimposed, so that the underlying and surrounding layers of paint showed through. The result was an uneven, vibrant surface imbued with movement by the varying reflections of the light that fell on it. In some paintings this impression could be heightened still further by the use of coarse-textured canvases and broad brushes that were old and unevenly worn. Also responsible for vibrancy, in addition to the brushwork, were the colors. In the waterlily paintings Monet's palette, which was essentially limited to five colors, excluded gray values when producing the chiaroscuro effects that academic landscape painters regarded as an important aid to the traditional representation of space. Instead, in line with Delacroix, he used the luminous values of colors, building up his pictures with hues of roughly equal strength. He used light-dark, warm-cold, and complementary contrasts, and executed color modulations from yellow-orange to red, via violet-blue, to green. In these paintings the brushstroke's representational and pictorial functions are therefore inseparable. To Bernheim-Jeune, he wrote:

As for the colors I use, what's so interesting about that? I don't think one could paint better or more brightly with another palette. The most important thing is to know how to use the

Waterlilies, 1914-17

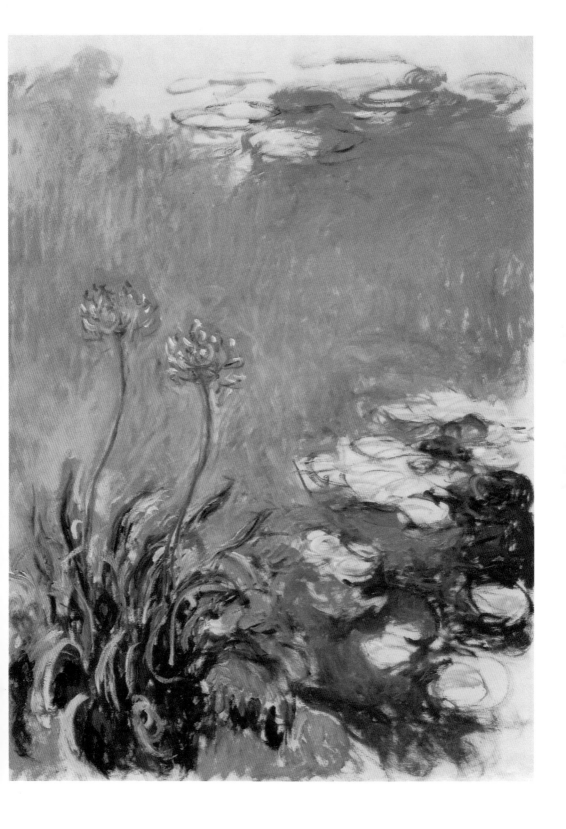

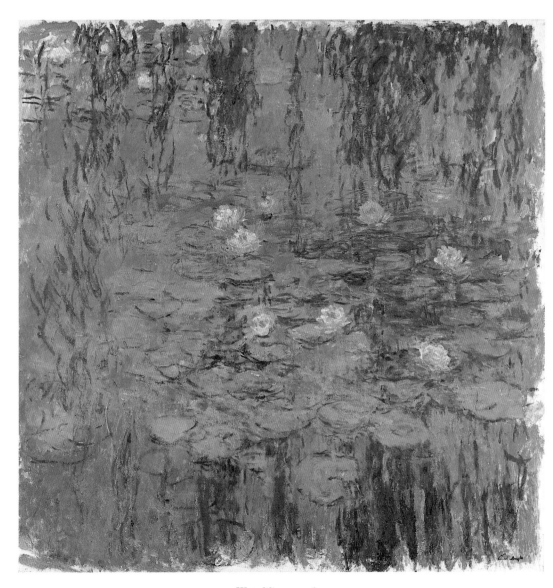

Waterlilies, 1916-19

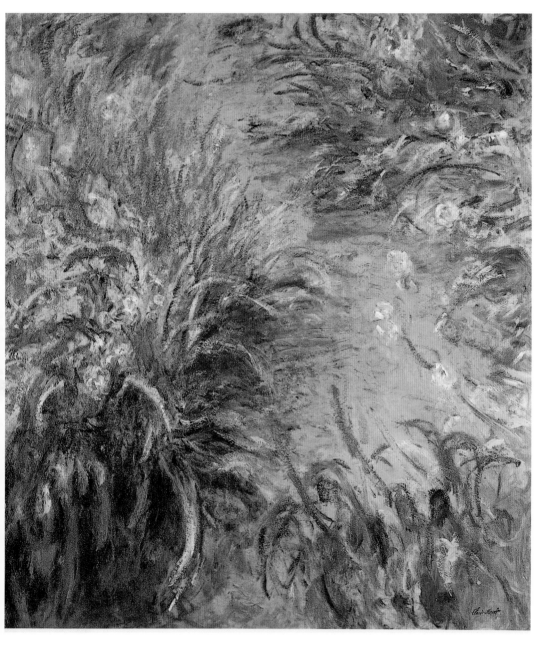

Path through the Irises, 1918-25

colors. Their choice is a matter of habit. In short, I use white lead, cadmium yellow, vermilion, madder, cobalt blue, chrome green. That's all.[32]

Although Monet was forever bemoaning his fate, given his age, his eye trouble, and the monumental size of the planned decoration, he threw himself into his work with such enthusiasm that he suffered from spells of exhaustion and had to take involuntary rests. In November 1917, however, Durand-Ruel received some preliminary photographs (pp. 70-71) which indicated that work on the waterlily decoration had reached an advanced stage. These photographs show a dozen-odd wide-format pictures of waterlilies mounted on easels equipped with wheels, so that they could be freely rearranged. Detailed descriptions of the already discernible decorative program were given by the art critic Thié-bault-Sisson[33] and the dealers Bernheim-Jeune and René Gimpel[34] after a visit to Giverny in 1918. It seems that Monet had arranged twelve canvases in a circle to create the impression that his guests were looking at a panorama of the water garden. Their imaginary stroll took them across the wisteria-covered Japanese bridge, past the irises (and the rose-covered gate), past the broad, open expanse of water with its reflected clouds, to the agapanthus lilies and, eventually, the willows on the opposite side of the pond. The photographs of 1917 do, in fact, prove that Monet had transposed the four central views of the pond. But the waterlily landscapes are far from displaying the naturalism characteristic of the extremely popular panoramic pictures of the time. Panoramas came about through a new representational technique that had—like photography—developed in the nineteenth century. They were housed in rotundas and took the form of self-contained, circular depictions of landscapes or historical events. In the middle of the chamber was a raised viewing platform, and those who beheld the panorama were meant to succumb to the illusion that they were looking at real scenery rather than a painting.

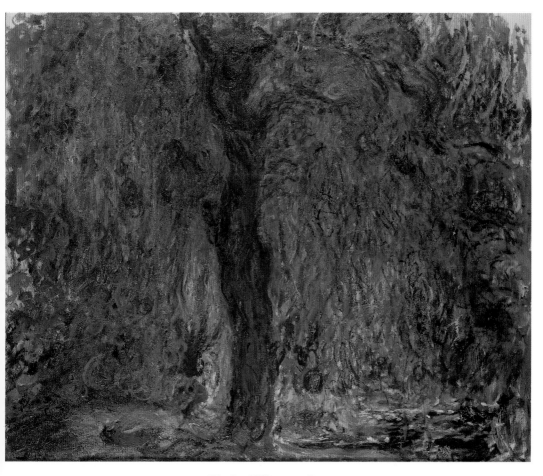

Weeping Willow, 1918-19

In this context, Monet's reflected landscapes should be construed as a synthesis of impressions gleaned from memory as well as from close observation on the spot. Thiébault-Sisson's recollection of the artist's remarks on this subject is as follows:

I had always, since my sixtieth year [around 1900], contemplated making a synthesis of each of the categories of subjects to which I had devoted my attention; a synthesis in which I would combine my former impressions and perceptions in one picture, or sometimes in two. I refrained from doing so. I would have had to travel much and far, revisit all the staging posts in my painter's career, and reexamine my original perceptions. I told myself, while I was painting my sketches [for the waterlilies], that a series of overall impressions, recorded during the hours when my vision had the greatest prospect of being accurate, would not be uninteresting. I waited until the idea had taken shape, until the arrangement and composition of the motifs had gradually inscribed itself on my brain....[35]

For Monet, therefore, painting became a means of projecting subjective sensations and nature became a metaphor. In these descriptive landscapes Monet achieved a many-layered juxtaposition of temporal planes, of inward and outward reality, in which the repetition of individual types of composition played as much of a role as the serial mode of procedure. There are unmistakable congruities here with the Symbolist literature of Stéphane Mallarmé and Marcel Proust, the latter of whom directly conjured up Monet's late work through the painter Elstir in his *Remembrance of Things Past*. For Proust, Monet's waterlily landscapes—like Elstir's landscapes—defy concrete definition because of a "metamorphosis," a many-layered temporal juxtaposition of past and present, a correspondence between landscape and perception.[36] Mallarmé, too, rejects any precise description of things, any illusionist reproduction of reality along naturalistic lines. Only consideration of the artist's material, only

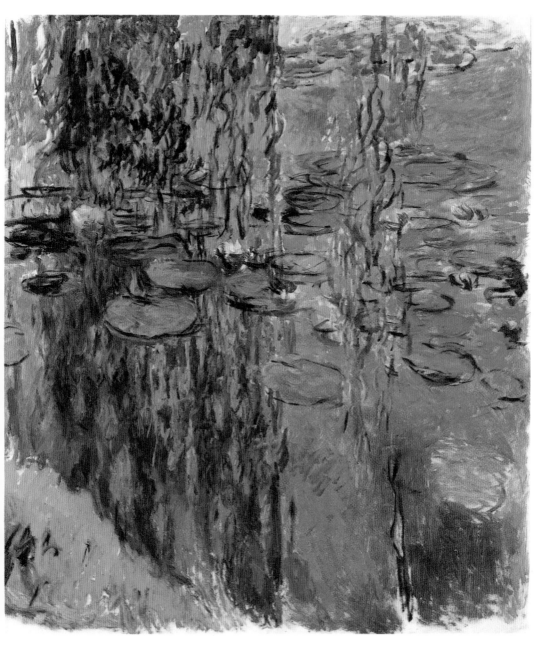

Waterlilies, 1916-19

allusion, suggestion, and *"correspondances"*—in other words, am-
biguity and openness, which to Mallarmé were essential features
of modern (Impressionist) art—can help to convey a perception
of the deeper realities.[37] In this sense, Mallarmé's prose poem
The White Waterlily, composed in 1885, reads like a description
of Monet's waterlily paintings. Monet greatly admired Symbolist
literature, and his extensive library contained numerous works
by Symbolist writers, Mallarmé and Mirbeau being his special
favorites. His water-garden paintings, with their waterlilies, re-
flections, and expanses of still water, embody motifs that were
extremely common in Symbolist literature and painting around
the turn of the century.[38] The opening of waterlilies is not de-
pendent on the sun's position alone; they thrive only in warm,
marshy, undisturbed water. As a symbol of feminine fertility,
therefore, the waterlily was thematically associated with the "still
waters" found in pools, ponds, and aquariums. These, in their
turn, are to be found in gardens or parks, which—artificially
secluded from the outside world—symbolize realms of the soul,
or "interiors." And, finally, there is the relationship between the
motif of reflection and the theme of Narcissus current in litera-
ture and painting around the turn of the century. Narcissus, a
figure from Greek mythology, pined away for love of his own
reflection in a pool. Thus, he symbolizes the undefined, frag-
mented self devoid of characteristic features. As an aesthetic aid,
reflection helps to divest a picture of its descriptive, mimetic
function, because a reflected object loses its firm, circumscribed
individuality and, by merging with its own mirror image, be-
comes part of a new, expanded unity.

In November 1918, having earlier toyed with the idea of be-
queathing two large waterlily pictures to the French government
to mark the end of the First World War, Monet was persuaded
by Clemenceau to present his waterlily decoration in its entirety
to the state.[39] Clemenceau, celebrated for his firm political
stance during the war, made exceptional efforts to sponsor this
scheme in the years that followed. Monet waited in vain for

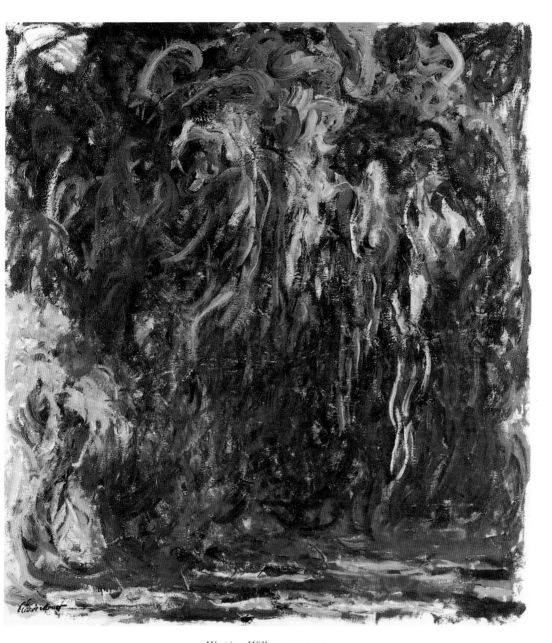

Weeping Willow, 1920-22

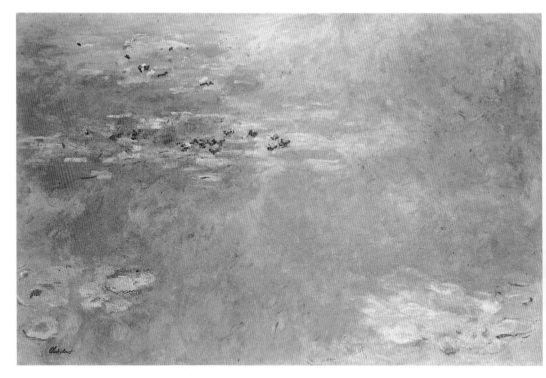

Waterlilies, 1917-19

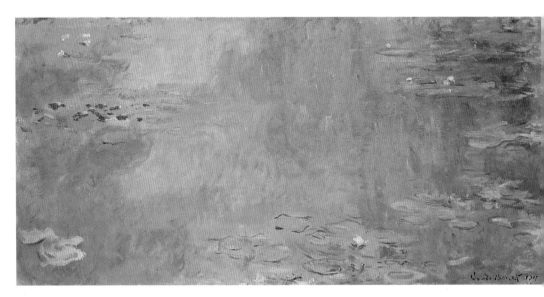

Waterlilies, 1917-19. Detail opposite

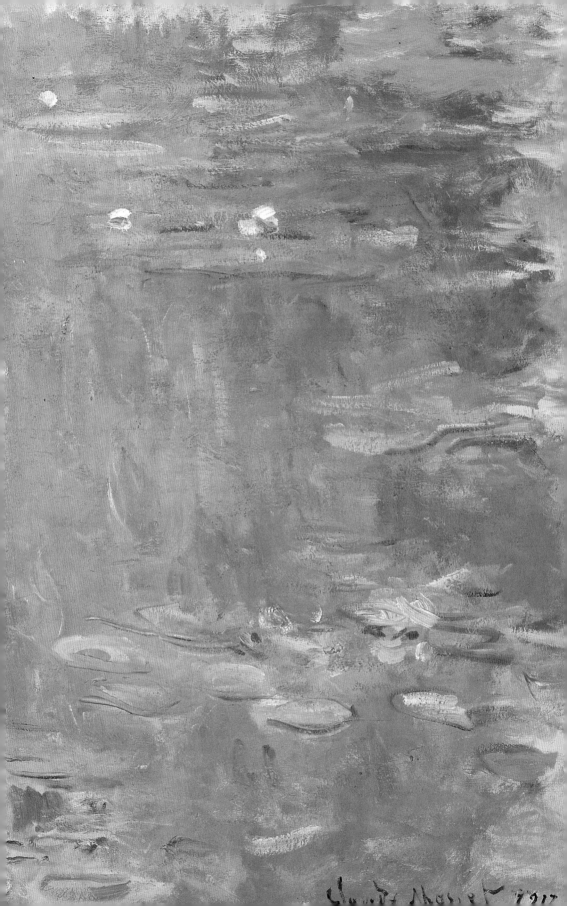

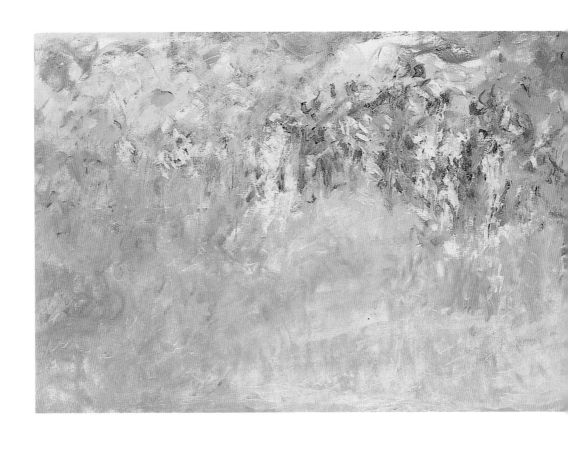

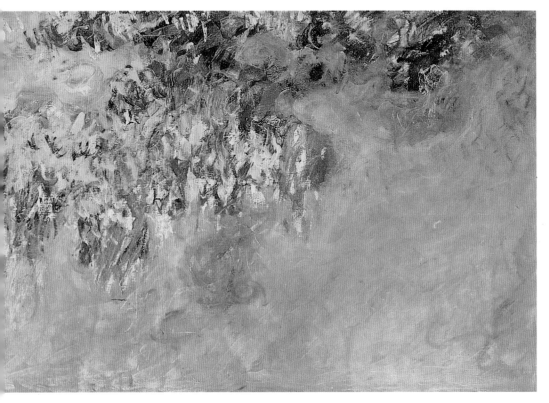

Wisteria, ca. 1920

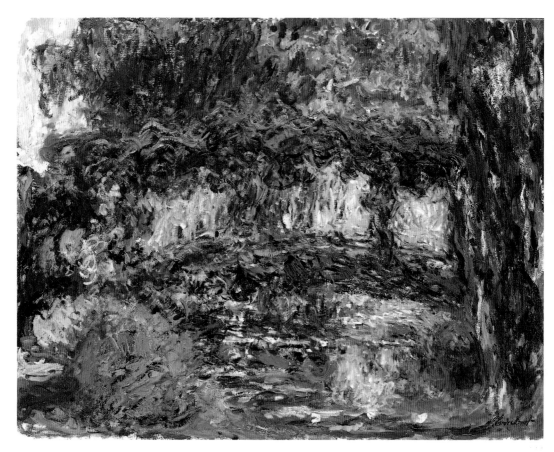

Japanese Bridge, ca. 1923

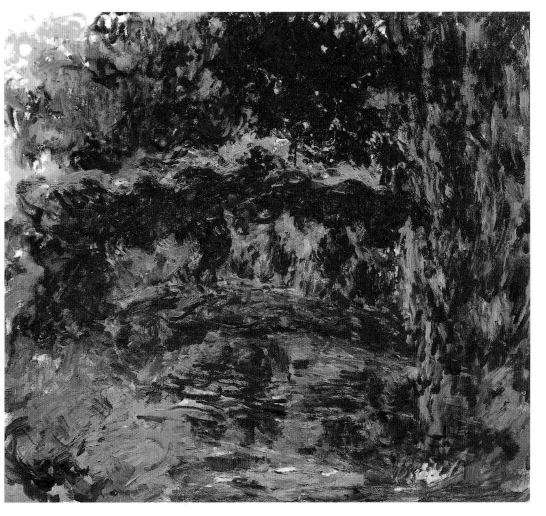

Japanese Bridge, ca. 1923

parliament to accept his bequest and offer him a suitable place to house it, his preference being for a rotunda. In February 1920, disappointed by this lack of response, he contacted some dealers and collectors. The Japanese dealer Matsukata, whom Clemenceau brought to Giverny, expressed great interest in the decoration, as did an American collector from Chicago. If these potential purchasers had also mounted the ensemble in accordance with the artist's plans, the paintings would have left France for good. Although Monet was opposed to this idea, Matsukata did acquire one of the waterlily pictures for more than 200,000 francs. In 1920, because of certain indiscreet reports on the part of Thiébault-Sisson, who was planning a monograph on Monet and had access to his correspondence, details of the decoration became publicly known.[40] It appeared that 12 waterlily pictures over 13 feet wide were to be mounted as four triptychs—*Irises, Cloud Reflections, Agapanthuses,* and *Willows*—in a circular, purpose-built room in the garden of the Hôtel Biron in Paris, now the Musée Rodin. Also planned were decorative friezes depicting wisteria in isolation from the Japanese bridge (pp. 84-85). With this scheme in mind, Monet tackled these subjects in two different formats during 1919-20.

Despite the intervention of some influential politicians, such as the Duc de Trevise,[41] the Hôtel Biron project never materialized. Monet's hopes dwindled, not least because of Clemenceau's failure to win the presidential election in January 1920. Consequently, despite Clemenceau's opposition, he endeavored to revoke his generous undertaking to present the waterlily pictures to the nation. A retrospective organized by Bernheim-Jeune in February 1921 clearly demonstrated the great demand for his work that existed in other quarters. At 300,000 francs apiece, prices for Monet's paintings were reaching astronomical heights, and his commercial instinct had taught him how to boost their market value. In the same year his *Women in the Garden* (1866; Musée d'Orsay, Paris) was sold to the French government for 200,000 francs.

View of the House from the Rose Garden, 1922

Clemenceau finally succeeded in persuading Monet to continue work on the decoration, and by April 1921 the possibility of housing his bequest in the Paris Orangerie was already under discussion. Because its two hall-shaped rooms confronted Monet with a layout entirely different from that of the planned rotunda at the Hôtel Biron, he abandoned the idea of a panoramic representation of his water garden. The pictures now in the Orangerie no longer correspond exactly to the topography of the water garden at Giverny. Nevertheless, they form a synthesis of Monet's years-long preoccupation with the subject; thus all these water landscapes should be construed in relation to this "apotheosis" of the water garden.

The deed of gift signed by Monet and the Ministry of Fine Arts in April 1922 initially covered nineteen pictures. According to an architectural plan of 1922, these would be housed in two oval, converted rooms in the Orangerie, to be known as the Musée Claude Monet. Monet's conditions were that the premises and the whole ensemble should never be altered, and that the paintings, which were enclosed within narrow white wooden frames, should not have their brilliant colors dulled by varnish. For the first room Monet planned four pictorial themes each composed of several canvases: *Setting Sun*, 20 feet wide; *Morning* and *Clouds*, each spanning 39 feet; and *Green Reflections*, 26 feet wide. The second room, too, was to contain four works: *Tree Reflections*, spanning 26 feet; *Morning with Willows*, over 39 feet wide; *Fine Morning with Willows*; and the 56-foot *Two Willows*. Subject only to minor modifications, this grouping corresponds to the present arrangement at the Orangerie.

On several occasions, Monet's eye trouble and the operation he underwent in 1923 forced him to stop work on finishing and assembling the decoration. In 1924, however, with his eyesight sufficiently improved by the wearing of new glasses and his spirits raised by the great success of a retrospective at the Galerie Petit, he readdressed himself to the Orangerie project with fresh enthusiasm.

View of the House from the Rose Garden, 1922

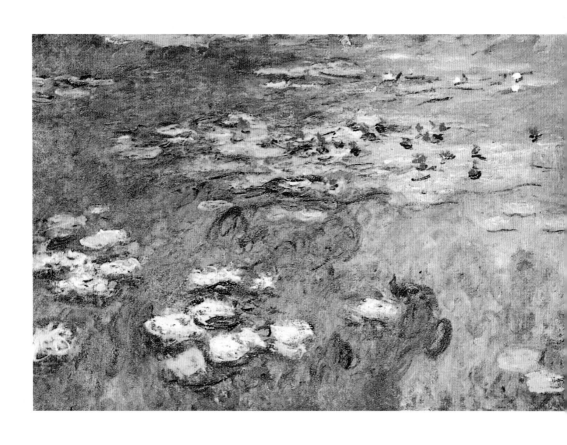

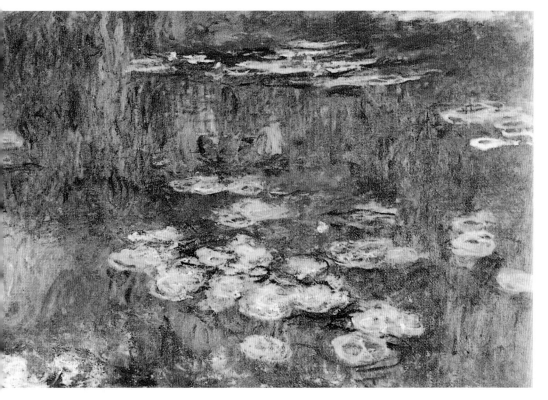

Waterlilies, 1916-22

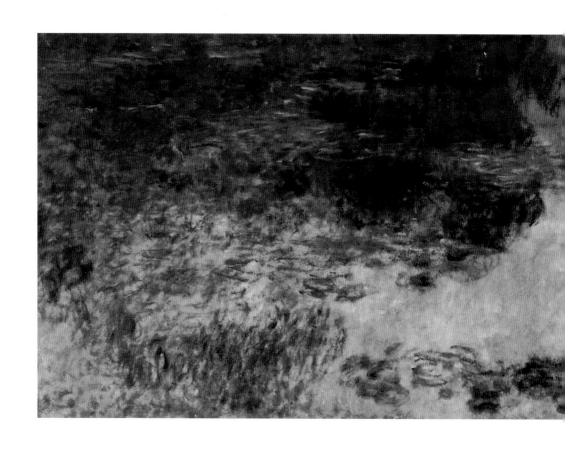

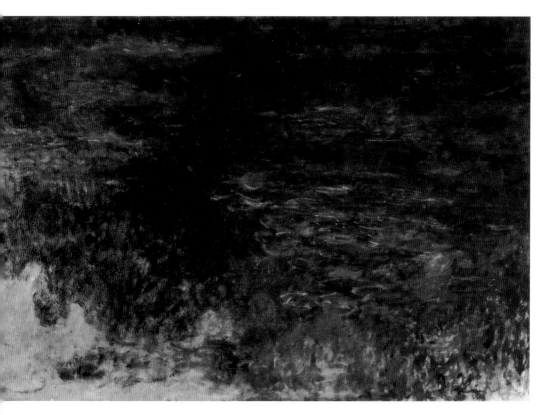

Waterlilies in the Evening, 1916-22

At the same time, he also reverted to the Japanese bridge theme. Compared to his bridge paintings from the turn of the century, these display such vivid coloration, autonomous, expressive brushwork, and formal dissolution, that the Japanese bridge motif itself is only hinted at (see pp. 86-87). Similar pyrotechnics of color can be observed in Monet's contemporary paintings of his rose garden (see pp. 89, 91), whose crucial feature is not the subject itself but the artist's subjective view of it. His state of health remained stable for a short time only. In the late summer of 1926, by which time his sight had almost completely deteriorated, Monet became bedridden as the result of pulmonary sclerosis brought on by heavy smoking. Just several weeks following, he died on December 5, 1926, with his family around him and his faithful friend Georges Clemenceau at his side.

Monet never saw his waterlily decoration installed in the Orangerie in its final form. In April 1927, after much consultation, twenty-two of the canvases were affixed to the Orangerie's curved walls by means of *marouflage* (a traditional method of adhesion). They went on display in May of that year. Clemenceau was soon complaining of the public's consequent lack of appreciation of the works in the Orangerie, which did not fit into any contemporary artistic category. With Constructivism in the ascendant, the whole of Monet's late work fell into oblivion and it was not until the 1950s that art critics and avant-garde artists of the younger generation rediscovered it. What primarily interested the generation of painters before the Second World War—Kasimir Malevich, Henri Matisse, Robert Delaunay, and Piet Mondrian, for instance—was Monet's serial approach, whereas the exponents of Abstract Expressionism regarded his work as a precursor of a chromatically abstract pictorial language. Monet's late painting, which was essentially based on his perception of the natural world and had led to the dissolution of form, was now admired for its expressive and abstract qualities, its use of color and brushwork, and the autonomy of its

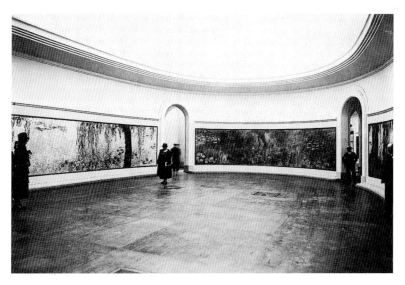

View of the rotunda at the Musée de l'Orangerie, 1927

artistic resources. The many American artists who have been stimulated by his late work include Sam Francis, a representative of the New York School such as Joan Mitchell, and the Canadian painter Jean-Paul Riopelle, who dedicated a series to Monet entitled *Nymphéas*. Pointing directly to his waterlily paintings, color and atmosphere are the predominant compositional elements in these abstract, all-over landscapes. Although the waterlily pictures in the Orangerie have always been accessible to the public, their rediscovery in France did not begin until the mid-1950s. The exhibition of Monet's late work at Katja Granoff's Paris gallery in 1956 and 1957 made an important contribution to that rediscovery. André Masson's reference to the Orangerie as "the Sistine Chapel of Impressionism" became proverbial; since then, millions of art lovers have made the pilgrimage to the "holy" halls.

The influence of the waterlily pictures and Monet's late work could be traced in the chromatically abstract painting of the present day. This justifies the art-historical reassessment of

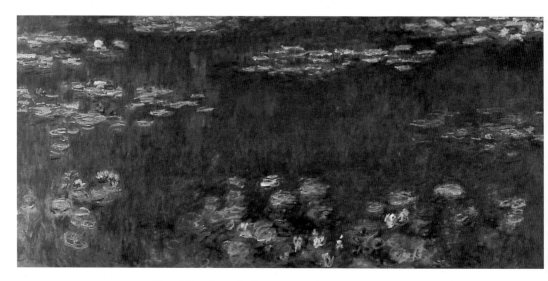

Waterlilies, Green Reflections, 1916-26. Detail opposite

Monet as a pioneer of modern art, a process that began in the 1960s.

In his waterlily paintings Monet finally broke with traditional pictorial ideas. Important developments in twentieth-century painting were anticipated by the deliberate open-endedness and ambiguity of these pictures with huge formats, whose lack of frames left them spatially unconstrained, and by the far-reaching autonomy of their artistic resources.

The traditional idea of the self-contained masterpiece lost ground to the serial conception that underlay Monet's paintings from the 1890s onward. The individual work forms part of a whole series, and is, at the same time, a reflection of it. In keeping with their serial open-endedness and extensibility, Monet wished his *Waterlilies* to remain unframed, and the Orangerie's space-embracing decoration vividly exemplifies this breaking of the traditional pictorial mold. In this sense, too, Monet's *Water-lilies* point the way to central endeavors in abstract painting since the advent of *Art Informel*. Spatial open-endedness and open pic-

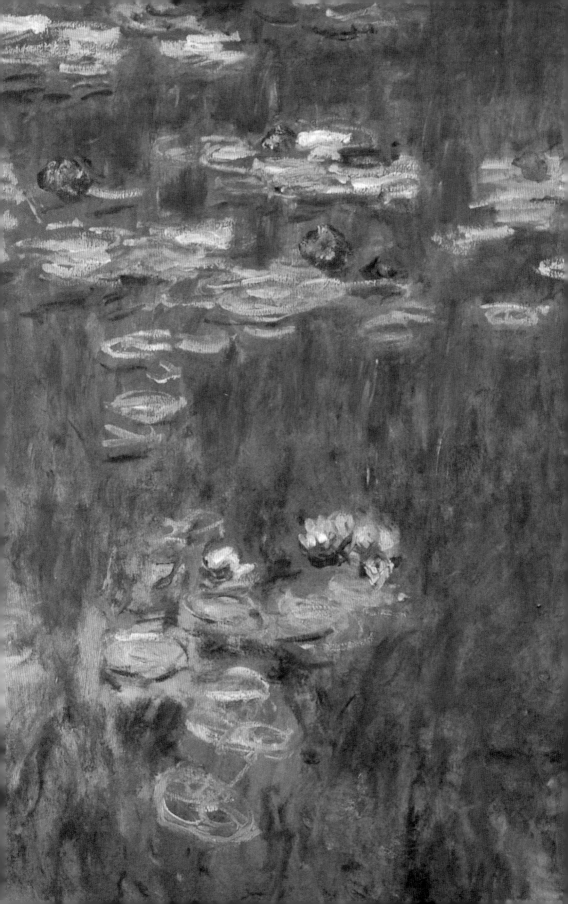

torial structures have their late nineteenth-century origins in ac-
celerated, fragmented forms of perception—occasioned by the
development of trains, automobiles, airplanes, etc.—and in the
associated destruction of traditional spatio-temporal experi-
ences. This blow to the self-contained, static picture of the world
was not only a result of the war, but also of the plethora of
scientific discoveries, which continue to color our notions of re-
ality to this day. The open, indeterminate, and ambiguous work
of art is thus directly related to a change in perception, a new
and dynamic conception of reality, a renewed perception of
space that retains its validity in the abstract color painting of
today. But, in contrast, the "open work of art" calls for greater
productive collaboration on the part of the beholder. It thus
confirms the enduring relevance of Monet's late work, and of
his fascinating *Waterlilies* in particular.

Monet at Giverny, ca. 1920

Biographical Notes

1840 Claude Oscar Monet, the second son of Claude-Adolphe and Louise-Justine Aubrée, is born in Paris on November 14.

Ca. 1845 His family moves to Le Havre, where Monet's father works in the wholesale business.

Ca. 1856 He draws his first caricatures. They are displayed in the shop windows of the frame-maker Gravier and Monet becomes a local celebrity.

1857 Monet's mother dies. His aunt assumes the role of his mother and encourages his artistic ambitions.

1858 Monet meets the landscape painter Eugène Boudin, who, as his first teacher, introduces him to *plein air* painting. His work, a landscape painting, appears for the first time in an exhibition in Le Havre. He applies, without success, for a scholarship in Paris.

1860 He works at the Académie Suisse in Paris, where he meets Camille Pissarro. Despite his family's wishes, he refuses to enroll in the Ecole des Beaux-Arts.

1861 He does military service with the *Chasseurs d'Afrique* in Algeria. Returns to France because of typhoid and leaves the army.

1862 Works at Charles Gleyre's *atelier libre*, where he becomes friends with Auguste Renoir, Alfred Sisley and Frédéric Bazille. In Le Havre he meets the Dutch landscape painter Johan Barthold Jongkind, whom he later refers to as his true master.

1863-64 Paints in the Forest of Fontainebleau and on the coast of Normandy. Prefers painting outdoors.

1865 Two of his seascapes, painted in Honfleur, are exhibited at the Paris Salon for the first time. In Fontainebleau Monet paints *The Picnic*, his first *plein air* work with lifesize figures.

1866 Meets his life companion Camille Doncieux, whose portrait *Camille*, also entitled *The Green Dress*, is shown at the Salon. Emile Zola is enthusiastic about this work.

1867 Shares Bazille's Parisian studio. His work is rejected by the Salon, but he makes plans with Renoir, Bazille, Pissarro, Sisley and Cézanne to set up independent exhibitions, the first of which takes place in 1874. His son Jean is born. His family insists on his separation from Camille, but Monet refuses and in 1869 his family withdraws all financial support. Works in Le Havre.

1868 In serious financial difficulties, Monet lives with Camille and Jean in Bennecourt, near Giverny. Makes several journeys to Normandy. Completes two portraits of the Gaudibert family and *The Breakfast.*

1869 Paints with Renoir at the Seine river resort La Grenouillère. In these works Monet achieves an atmospheric dissolution of the colored surface. The tonal dependence of his earlier works disappears.

1870 Monet marries Camille. At the outbreak of the Franco-German war of 1870-71, he seeks exile in London, wehre he meets his future art dealer Paul Durand-Ruel. Monet admires the work of the English landscape painters, especially that of J. M. W. Turner and John Constable.

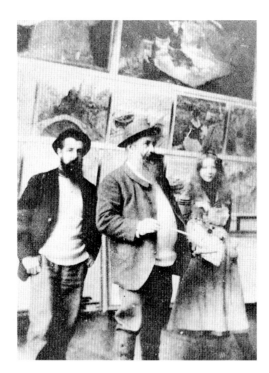

*Monet with his son Jacques
and daughter-in-law Anna, ca. 1900*

1871
Sojourns in Zaandam in Holland. Returns
to Paris and in 1878 settles in Argenteuil.
The years here mark the culmination of
French Impressionism.

1872-73 Paints river landscapes in and
around Argenteuil, in some cases from his
boat, and the *Boulevard des Capucines* in
Paris.

1874 In April the First Impressionist Ex-
hibition takes place at the gallery of the
Parisian photographer Félix Nadar. The
term "Impressionism" is used by Louis
Leroy in his facetious reference to Monet's
Impression, Sunrise (1872), which causes a
scandal. Nevertheless, the group organizes
seven additional exhibitions up to 1886.

1875 Paints snowscapes in Argenteuil.

1876 Second Impressionist Exhibition.
Makes the acquaintance of the art patron
Ernest Hoschedé, who invites him to stay in
his château in Montgeron to produce a
series of decorative paintings. Camille falls
ill. In Paris works on the first series of Gare
Saint-Lazare paintings.

1877 Third Impressionist Exhibition.
Slow sales lead to serious financial prob-
lems.

1878 Moves to Paris. Birth of his sec-
ond son Michel. Camille is seriously ill.
Moves to Vétheuil, where Alice Hoschedé
follows him with her six children. Bur-
dened by Camille's illness and their desper-
ate financial situation, Monet paints somber
winter landscapes in Vétheuil and Lava-
court.

1879 Fourth Impressionist Exhibition. Camille dies. Monet paints winter scenes void of human figures, and pictures of drift ice.

1880 Does not participate in the Fifth Impressionist Exhibition. First solo exhibition at Georges Charpentier's publishing house. Wins several new customers. Paints landscapes of the rocky coast of Normandy.

1881 Does not participate in the Sixth Impressionist Exhibition. Durand-Ruel is successful in selling his work. Paints in Vétheuil and Fécamp on the coast of Normandy. Moves to Poissy. Alice decides to stay with Monet and not to return to Ernest Hoschedé.

1882 Works in Dieppe and Pourville. His views of Vétheuil and Fécamp are well received at the Seventh Impressionist Exhibition.

1883 Paints in Le Havre and Etretat. Solo exhibition in Durand-Ruel's gallery. Produces a series of paintings for Durand-Ruel's home. In April he settles in Giverny. Works in Vernon and travels with Renoir to the Riviera.

1884 On the Riviera Monet paints in Bordighera and Menton. Spends the summer in Etretat. Meets Octave Mirbeau.

1885 Paints snowscapes in Giverny and seascapes in Etretat. Friendship with Guy de Maupassant.

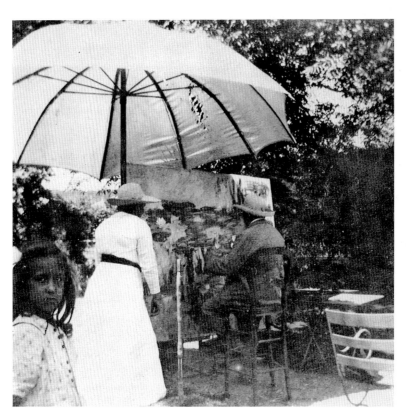

Monet painting out-of-doors in July 1915.
Just left of him are his daughter-in-law Blanche and his granddaughter

Monet and Theodore Butler

1886 Monthly meetings of the Impressionists at Café Riche in Paris. Emile Zola publishes *L'Œuvre*, which describes the life of a painter and was probably based on Cézanne. Monet and Cézanne are incensed. Durand-Ruel successfully organizes an Impressionist exhibition in New York. Participates in the Eighth (and last) Impressionist Exhibition. In Brittany, Monet paints views of Belle-Ile-en-Mer that are shown in Georges Petit's gallery in Paris the following year. Meets the poet Stéphane Mallarmé and Gustave Geffroy, his later biographer.

1888 Works in the vicinity of Antibes. Travels to London. Exhibitions in Paris at the galleries of Georges Petit and Boussod et Valadon. Produces his first painting of haystacks.

1889 Travels with Geffroy to Fresselines. Solo exhibition in Paris at Boussod et Vala-

don's and in London at Goupil's. Extensive retrospective exhibition with Auguste Rodin.

1890 Paints his first *Grain Stacks* series. Buys the house in Giverny.

1891 Solo exhibition at Durand-Ruel's gallery, showing the *Grain Stacks* series. Begins work on the *Poplars* series. Travels to London, visits James McNeil Whistler.

1892 Exhibition of the *Poplars* series at Durand-Ruel's gallery. Marries Alice Hoschedé, a widow since 1891. Suzanne Hoschedé marries the American painter Theodore Butler. Monet begins a new series, *Rouen Cathedral* (finished in 1894).

1893 Paintings of drift ice on the Seine near Bennecourt and Port-Villez. In Giverny acquires a plot of land adjoining the house and creates a Japanese water garden on it. Works on the *Rouen Cathedral* series.

1894 The American painter Mary Cassatt and Paul Cézanne visit Monet in Giverny.

1895 Travels to Norway with his step-child Jacques Hoschedé. The Japanese bridge in his water garden is built.

1896 Works in Dieppe, Pourville, Varengville. Begins the *Early Morning on the Seine* series.

1897 Jean Monet marries Blanche Hoschedé. Completes the *Early Morning* series. Plans the *Waterlily* series.

1898 Solo exhibition at Georges Petit's gallery, where the *Early Morning* series is shown.

1899 Paints winter scenes, the Japanese bridge and his garden. In London, paints the Thames and Houses of Parliament. Solo exhibition at Durand-Ruel's gallery, where paintings of his water garden are shown for the first time.

1901 Paints in London and Vétheuil. Enlarges the waterlily pond.

1902 Completes the water garden. Solo exhibition at Durand-Ruel's gallery in New York.

1903 Begins the series of waterlily paintings, which he continues in 1908.

1904 Enormously successful solo exhibition of London paintings at Durand-Ruel's gallery. Travels with Alice to Madrid, where he admires the paintings of Velázquez. Sojourns in London. In the following years works almost entirely on the *Waterlily* series.

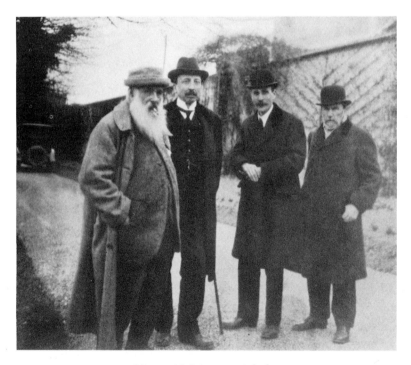

Monet with Japanese art dealers

Monet and Alice Monet-Hoschedé at the Piazza San Marco in Venice, 1908

1908 First symptoms of cataract. Travels with Alice to Venice, begins a *Venice* series, on which he works until 1912.

1909 Alice falls seriously ill. Successful solo exhibition of the *Waterlily* series (1903-8) at Durand-Ruel's gallery. Postpones second journey to Venice because of his poor health.

1910 His garden is flooded.

1911 Solo exhibition at Durand-Ruel's gallery in New York. Alice dies.

1912 Exhibition of the *Venice* series in Bernheim-Jeune's Paris gallery.

1914 Jean Monet dies. Blanche Hoschedé takes over the household in Giverny. Extensive retrospective at Durand-Ruel's gallery. Monet works on the *Waterlily* series again.

1915 Makes plan for a large *Waterlily* series. A third studio is built to accommodate the large formats.

1917 Works on the large *Waterlily* series and paints on the coast of Normandy.

1918 From now until 1924 the Japanese bridge appears repeatedly in Monet's work. At the end of the war Monet offers the French government two *Waterlily* paintings for the Musée des Arts Décoratifs. Clemenceau and Geffroy encourage him to make a substantial gift.

1919 Has serious problems with his eyesight. Clemenceau advises him to have the cataract operated on.

1920 Negotiations with the French government over his gift of *Waterlilies* for the rotunda of the Hôtel Biron (today the Musée Rodin) fail for financial reasons.

1921 Retrospective at Bernheim-Jeune's gallery. Monet agrees to the installation of the *Waterlilies* at the Musée de l'Orangerie in Paris.

1922 Signing of the deed of gift. Gustave Geffroy publishes his monograph. Because of his failing eyesight, which is treated by the eye specialist Dr. Coutela, Monet is forced to cease working for longer periods.

1923 Operations on his right eye. Monet initially has difficulties distinguishing colors but resumes work on the *Waterlilies* immediately after the symptoms have abated.

1924 Retrospective at Georges Petit's gallery. New glasses improve his eyesight, but only for a short period. Fears that he will not be able to complete the *Waterlily* series.

1926 Falls ill and finally stops painting. Dies on 5 December.

1927 The *Waterlily* series at the Musée de l'Orangerie in Paris is officially unveiled on 17 May.

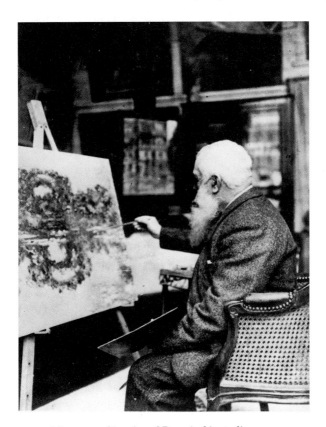

Monet reworking Arc of Roses in his studio, 1920

Monet under the rose-covered gate, 1926

Notes

1 Musée Claude Monet, Rue Claude Monet, 27620 Giverny; for further information see the official guide by G. van der Kemp, *Une visite à Giverny*, Versailles 1980. Particularly recommended for their wealth of documentary photographs are two publications by C. Joyes, *Monet at Giverny*, London 1975, and *Life at Giverny*, London 1985.

2 Musée de l'Orangerie, Place de la Concorde, 75001 Paris. See M. Hood, *Les Nymphéas de Claude Monet au Musée de l'Orangerie*, Paris 1984.

3 P. H. Tucker, *Monet at Argenteuil*, New Haven and London 1982.

4 Monet's acquaintanceship with the Paris art dealer Paul Durand-Ruel dated from 1870. They first met in London, where the artist had taken refuge during the Franco-Prussian War. Durand-Ruel subsequently became one of the Impressionists' earliest and most enthusiastic promoters. See L. Venturi, *Les Archives de l'impressionnisme: Lettres de Renoir, Monet, Pissarro, Sisley et autres: Mémoires de Paul Durand-Ruel*, New York 1968. Much documentary material is still held by the Galerie Durand-Ruel, Paris.

5 Letter to Durand-Ruel dated June 5, 1883, in L. Venturi, op. cit., pp. 255-56.

6 Monet owned the diaries of Eugène Delacroix (*Journal I-III*, 1893-95), which he greatly enjoyed reading and kept within reach of his bed.

7 Neo-Impressionist painting was publicly inaugurated at the first Salon des Indépendants in 1884 by Georges Seurat's *Bathers, Asnières* (1883-84), and was primarily based on Michel Eugène Chevreul's theory of simultaneous color contrast (*De la loi du contraste simultané des couleurs*, 1839 and 1869), the scientific treatises of Hermann Helmholtz, and the Gestalt theories of Charles Blanc (1867).

8 See André Wormser, "Claude Monet et Georges Clemenceau: une singulière amitié" in J. Rewald and F. Weitzenhoffer, *Aspects of Monet: A Symposium on the Artist's Life and Times*, New York 1984, pp. 189-217 and Georges Clemenceau, *Claude Monet: Cinquante ans d'amitié*, Paris 1926.

9 Octave Mirbeau, *Correspondance avec Claude Monet*, Tusson 1990.

10 Letter to Alice Hoschedé dated April 3, 1892, in Daniel Wildenstein, *Claude Monet: Biographie et catalogue raisonné*, III, Letter 1146, Lausanne/Paris 1979.

11 Monet in conversation with the Duc de Trévise (1920). See the latter's "Le Pèlerinage de Giverny," *Revue de l'art ancien et moderne*, 1927, p. 22.

12 Gustave Geffroy, *Claude Monet: Sa vie, son œuvre*, Paris 1922; rev. ed. 1980, p. 308.

13 Georges Clemenceau, *Claude Monet: Cinquante ans d'amitié*, Paris 1926, pp. 145-46.

14 Monet's memoirs, which were occasionally embellished for the benefit of posterity, give various dates for the discovery and acquisition of his first Japanese prints. Dates in the region of 1856 are quite implausible, however, because Japanese art was not "discovered" and disseminated in Paris until the 1860s. See Geneviève Aitken and Marianne Delafond, *La Collection d'estampes japonaises de Claude Monet*, Neuchâtel 1983.

15 Henri Bergson, *L'Evolution créatrice*, Paris 1907; *Creative Evolution*, London 1911.

16 See Karin Sagner-Düchting, "Claude Monet: Nymphéas, Eine Annäherung," *Studien zur Kunstgeschichte*, 32, Hildesheim, Zurich, New York 1985, p. 23.

17 Wassily Kandinsky, *Gesammelte Schriften I*, Bern 1980, p. 32.

18 A lovingly compiled collection of Monet's recipes can be found in Claire Joyes, *Les Carnets de cuisine de Monet*, Paris 1989.

19 L. C. Perry, "Reminiscences of Claude Monet," *American Magazine of Art*, 18, March 1926, p. 120.

20 Maurice Guillemot, "Claude Monet," *La Revue illustrée*, March 15, 1898.

21 Daniel Wildenstein, *Claude Monet: Biographie et catalogue raisonné*, IV, Letter 1893, Paris 1985.

22 Louis Vauxcelles, "Un Après-midi chez Claude Monet," *L'Art et les artistes*, December 1905, pp. 85-90.

23 Louis Gillet, "L'Épilogue de l'impressionnisme: Les Nymphéas de Claude Monet," *La Revue hebdomadaire*, August 21, 1909.

24 Letter to Gustave Geffroy dated August 11, 1908, in Daniel Wildenstein, *Monet: Biographie et catalogue raisonné*, IV, Letter 1854, Lausanne and Paris 1985.

25 Letter to Gustave Geffroy dated September 5, 1908, ibid., Letter 1857.

26 Letter to Durand-Ruel dated April 27, 1907, ibid., Letter 1832.

27 Arsène Alexandre, "Les Nymphéas de Claude Monet," *Le Figaro*, May 7, 1909.

28 Roger Marx, "Les Nymphéas de Claude Monet," *Gazette des Beaux-Arts*, I, 1909, p. 529.

29 Georges Clemenceau, *Claude Monet: Cinquante ans d'amitié*, Paris 1926.

30 Letter to Durand-Ruel dated June 29, 1914, in Daniel Wildenstein, *Claude Monet: Biographie et catalogue raisonné*, IV, Letter 2123, Lausanne and Paris 1985.

31 Lucien Descaves, "Chez Claude Monet," *Paris Magazine*, August 25, 1920.

32 Letter to Bernheim-Jeune dated June 3, 1905. See L. Venturi, *Les Archives de l'impressionnisme*, I, p. 404. On Monet's use of color and technique, see John House, *Claude Monet: His Aims and Methods c. 1877-1895*, dissertation, Courtauld Institute of Art, London 1976; Robert Herbert, "Method and Meaning in Monet," *Art in America*, September 1979, pp. 90-108.

33 François Thiébault-Sisson, "Les Nymphéas de Claude Monet à l'Orangerie," *La Revue de l'art ancien et moderne*, June 1927, p. 48.

34 René Gimpel, *Journal d'un collectionneur: Marchand de tableaux*, Paris 1963, p. 68.

35 F. Thiébault-Sisson, op. cit.

36 Marcel Proust, "Les Eblouissements," *Le Figaro*, June 15, 1907.

37 Stéphane Mallarmé, "Les Impressionnistes et Edouard Manet 1875-1876," *Gazette des Beaux-Arts*, 86, 1976, pp. 147-65.

38 H. Zürcher, *Stilles Wasser, Narziss und Ophelia in der Dichtung und Malerei um 1900*, Bonn 1975; H. Jost, "Undinen-Zauber: Zum Frauenbild des Jugendstils," *Der Schein des schönen Lebens: Studien zur Jahrhundertwende*, Frankfurt 1972, pp. 147-79.

39 Gustave Geffroy, "Claude Monet," *L'Art et les artistes*, November 3, 1920, pp. 80-81.

40 François Thiébault-Sisson, "Claude Monet," *Le Temps*, April 6, 1920, and "Un don de Claude Monet à l'État," ibid., October 14, 1920.

41 It was in this connection that the Duc de Trévise, a parliamentarian, attended Monet's birthday celebrations at Giverny in November 1920; see Note 11.

Selected Bibliography

*Monographs
and General Reading*

Geffroy, Gustave, *Claude Monet: Sa vie, son œuvre*, Paris 1924; rev. ed. Paris 1980.

Gerdts, William, *Monet's Giverny: An Impressionist Colony*, New York, London, Paris 1993.

Gordon, Robert and Forge, Andrew, *Monet*, New York 1983.

Hoog, Michel, *Les Nymphéas de Claude Monet au Musée de l'Orangerie*, Paris 1984.

Hoschedé, Jean-Pierre, *Claude Monet: Ce mal connu*, Geneva 1960.

House, John, *Monet: Nature into Art*, London 1986.

Joyes, Claire, *Monet at Giverny*, London 1975.

——, *Claude Monet: Life at Giverny*, London 1985.

——, *Les Carnets de cuisine de Monet*, Paris 1989.

Keller, Horst, *Ein Garten wird Malerei: Monets Jahre in Giverny*, Cologne 1982.

Patin, S., *Monet: Un œuil...mais, Bon Dieu, quel œuil*, Paris 1991.

Rouart, Denis and Rey, Jean-Dominique, *Monet: Nymphéas ou les miroirs du temps*, Paris 1972.

Rouart, Denis, *Monet*, Paris 1990.

Sagner-Düchting, Karin, "Claude Monet: Nymphéas, Eine Annäherung," *Studien zur Kunstgeschichte*, 32, Hildesheim, Zurich, New York 1985.

——, *Monet: A Feast for the Eyes*, Cologne 1992.

Seiberling, Grace, *Monet's Series*, New York and London 1981.

Seitz, William, *Claude Monet*, New York 1962.

Stuckey, Charles (ed.), *Monet: A Retrospective*, New York 1985.

Wildenstein, Daniel, *Claude Monet: Biographie et catalogue raisonné*, 4 vols., Paris 1974-85.

Articles Published in Periodicals

Durand-Ruel, Charles, "Monet: Le Destin des Nymphéas," *Connaissance des Arts*, 1980 (336), pp. 50-53.

Elderfield, John, "Monet's Series," *Art International*, XVIII, 1974, pp. 28-29, 45-46.

Gordon, Robert, "The Lily Pond at Giverny: The Changing Inspiration of Monet," *The Connoisseur*, 185, 1973 (741), pp. 154-65.

Gordon, Robert and Stuckey, Charles, "Blossoms and Blunders: Monet and the State," I, *Art in America*, 67, 1979 (1), pp. 102-17.

Levine, Steven Z., "Monet's Pairs (Monet's Strategy of the Series)," *Arts Magazine*, 49, 1975 (10), pp. 72-75.

Maurer, Emil, "Letzte Konsequenzen des Impressionismus. Zu Monets Spätwerk," *15 Aufsätze zur Geschichte der Malerei*, Basel, Boston, Stuttgart 1982, pp. 181-93.

Stuckey, Charles F., "Blossoms and Blunders: Monet and the State," II, *Art in America*, 67, 1979 (5), pp. 109-25.

Usener, Karl Hermann, "Claude Monets Seerosenwandbilder in der Orangerie," *Wallraf-Richartz Jahrbuch*, XIV, 1952, pp. 216-25.

Exhibition Catalogues

Monet's Years at Giverny: Beyond Impressionism, introduction by Charles S. Moffet and James N. Wood; The Metropolitan Museum of Art, New York 1978.

Hommage à Claude Monet, contributions by Hélène Adhémar, Anne Distel, and others; Grand Palais, Paris 1980.

Claude Monet au temps de Giverny, contributions by Maurice Guillaud, Jean-Marie Toulgouat, Claire Joyes, and others; Centre Culturel du Marais, Paris 1983.

A Day in the Country: Impressionism and the French Landscape, contributions by Richard Brettell and others, Los Angeles County Museum of Art; Los Angeles 1984.

SELECTED BIBLIOGRAPHY

Claude Monet: Painter of Light, contributions by John House and Virginia Spate; Auckland City Art Gallery, Auckland 1985.

Claude Monet: Nymphéas, Impression, Vision, contributions by Christian Geelhaar and others, Kunstmuseum Basel, Basel 1985.

Monet in the 90's: The Series Paintings, Museum of Fine Art, Boston; Art Institute of Chicago; Royal Academy of Arts, London 1990.

List of Illustrations

Illustrations have been listed in the order that they appear.

The numbers prefaced "W" refer to Daniel Wildenstein's catalogue raisonné.
For full publication details see the Selected Bibliography on p. 113

Photograph Credits

Galerie Beyeler, Basel: p. 77;
Photographie Giraudon,
Vanves: pp. 82-83; The Minne-
apolis Institute of Arts: p. 87;
Musée d'Orsay, Paris: pp. 27,
74; Philadelphia Museum of
Art: p. 42; Karin Sagner-
Düchting, Munich: pp. 8-9, 23,
25, 52; Shelburne Museum,
Shelburne, Vermont: pho-
tograph by Ken Burris: p. 47

A farewell to Giverny, 1926

© Prestel Verlag, Munich · London · New York, 1999

Photograph credits on p. 118

Translated from the French (pp. 7, 10: Georges Clemenceau,
Claude Monet: Cinquante ans d'amitié, Paris 1926, pp. 65-66, 68-69)
and from the German by John Brownjohn
Biography translated from the German by Anne Heritage

Front cover: *Waterlilies*, ca. 1897-98 (detail), oil on canvas, 26 x 41 in.
(66 x 104 cm), Los Angeles County Museum of Art

Spine: *Monet's Garden at Giverny*, 1902 (detail),
oil on canvas, 35 x 36 $^3/8$ in. (89 x 92.5 cm), Kunsthistorisches Museum
der Stadt Wien, Vienna

Frontispiece: *Japanese Bridge, Harmony in Green*, 1899
(detail; see pp. 54 and 117)

Page 4: *Poppy Fields at Giverny*, 1885 (detail; see pp. 19 and 115)

Prestel-Verlag
Mandlstrasse 26, 80802 Munich, Germany
Tel. (89) 38 17 09-0; Fax (89) 38 17 09-35
4 Bloomsbury Place, London WC 1A 2QA, England
Tel. (0171) 323 50 04; Fax (0171) 636 80 04
and 16 West 22nd Street, New York, NY 10010, USA
Tel. (212) 627-8199; Fax (212) 627-9866

Lithography by Eurocrom
Typeset, printed and bound by Passavia, Passau
Typeface: Baskerville
Cover design: Matthias Hauer and Meike Weber

Printed in Germany

ISBN: 3-7913-2006-8 (paperback)
ISBN: 3-7913-1384-3 (hardback)